Photographing Nature

FUNGI

Heather Angel MSc FIIP FRPS

First Published 1975

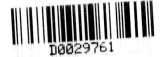

D0029761

FOUNTAIN PRESS, ARGUS BOOKS LIMITED
Station Road, Kings Langley, Hertfordshire, England

CONTENTS

INTRODUCTION

Fungi, so far, have not captured the imagination of photographers to the same extent as flowers or trees. This is no doubt partly due to the fruiting bodies of many fungi being ephemeral and intermittent in occurrence. It is therefore hoped that this book will introduce fungi to many naturalists and photographers who might otherwise have passed them by as a source of highly photogenic material, and also that it will provide mycologists with hints on photographic techniques.

Selecting which fungi to photograph will be a very personal choice, since it relates to how a photographer 'sees' the environment. A forester will clearly notice parasitic bracket fungi which attack his trees; a mycologist may concentrate on one genus at a time; an all-round naturalist who is aware of the different kinds, may wish to emphasize the intimate relationships between certain types of fungi and higher plants, or variety of shape and form; while the artist will be more involved in recording the shapes, patterns and designs that catch his eye at random.

Throughout this book a basic knowledge of photography has been assumed, so that the maximum amount of space could be devoted to the life and habitats of fungi as well as the specific techniques related to their effective photography. All photographic terms used in this book are defined in Appendix A and a summary of the equipment and accessories for photographing fungi is given in Appendix B. In common with other titles in this series, a practical approach has been adopted throughout, and the photographs have been specially selected to illustrate the majority of the techniques. All the monochrome and most of the colour photographs were taken on a Hasselblad camera. The remaining colour illustrations were taken with a Nikkormat camera.

To conform with the other titles, common names – where they exist – have been used throughout the text. However, since many of these colloquial names are not widespread, a species index has been compiled giving the up-to-date scientific names (at the time of going to press) together with the older and more familiar scientific names.

Amongst the fungi there are subjects which can provide a whole spectrum of shapes and patterns, for both the close-up enthusiast and the creative photographer.

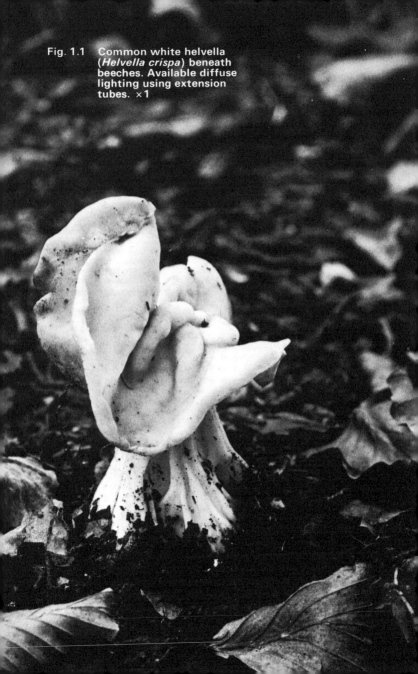

Fig. 1.1 Common white helvella (*Helvella crispa*) beneath beeches. Available diffuse lighting using extension tubes. ×1

Fungi have a remarkable range of form and colour, but unless they are purposely sought out, only the larger and more colourful kinds catch the eye. They grow in all manner of habitats: in complete darkness underground, on dung, underwater and, unfortunately for the photographer, on both films and lenses.

The best known fungi are the mushrooms and toadstools, which have a distinct stalk and cap. Generally, the term 'mushroom' is used rather loosely for the better known edible fungi, while 'toad-stool' refers to all other species especially the poisonous and un-palatable kinds. In Scotland, toadstools are known as puddock-stools. Throughout this book, all fungi with a stalk and a cap will be referred to as toadstools or agarics.

In addition to mushrooms and toadstools, the term fungus in-cludes members of inconspicuous but ecologically very important groups such as moulds, mildews, yeasts, rusts and smuts. The illustrations in this book have been selected to illustrate both the diversity of form and colour of fungi, as well as the different tech-niques for photographing them.

Classification

The prefix of the word used to describe the science of the study of fungi – mycology – is incorporated in the names of the major groups: the Phycomycetes, the Ascomycetes (sac fungi) and the Basidiomycetes (club-bearing fungi) are distinguished by their methods of sexual reproduction. A fourth artificial group is the Fungi Imperfecti in which asexual reproduction only occurs. The Phycomycetes can be recognised by the thin threads (hyphae) which they produce, often without the cross-walls found in the other two groups. Also, their reproductive organs are found in the branches of the individual hyphae and not aggregated into a fleshy fruit body. Phycomycetes are therefore minute fungi requiring a microscope for their study. Many are aquatic or live in damp places, the parasitic cottonwool fungus which attacks fish being an example (Fig. 4.8). Others cause plant diseases such as the destruc-tive potato blight, or grow on decaying vegetation and food as moulds. Generally, they will provide worthwhile subjects for the photographer only if very considerable magnifications are used. The Myxomycetes or slime moulds exhibit both plant and animal characteristics, but are sometimes classed with the fungi. They are probably best considered as a completely separate group.

Like seaweeds, liverworts, mosses and ferns, fungi reproduce by means of spores and not seeds. The way in which these spores are produced is the basic criterion used to distinguish the sac and the club-bearing fungi. Also, the size and shape of these microscopic spores are important for confirming the identification of some species. In the Ascomycetes (cup fungi, morels, yeasts and ergot) the spores are produced (usually in groups of eight) within an enclosed microscopic sac known as an ascus, whereas in the Basidiomycetes (mushrooms, toadstools, puffballs and bracket fungi), four (or two) spores are produced on the outside of club-shaped structures called basidia.

Sites for fungi

Fungi contain no green chlorophyll and so, unlike green plants, they are unable to synthesize their own food. The majority live on dead and decaying plant or animal matter and are therefore saprophytes, but a minority feed parasitically on living animal and plant hosts. Like many flowers and trees, each species of fungus tends to grow in a specific habitat. Knowing what kind of substrate a fungus lives on is half the battle towards finding it in the field. There is no organic material – either living or dead – of plant or animal origin, that is completely immune to attack by fungi. In a hot and humid tropical atmosphere, moulds grow rapidly over all kinds of clothing. They also grow on refrigerated foods.

The toadstool, mushroom or bracket is the reproductive stage (the fruiting body) which produces the spores. It grows up from a system of fine branching threads, known collectively as a mycelium (page 57) which penetrates the food source. The time a fungus takes to develop its fruiting bodies can vary from weeks to years. Cultivated mushrooms will form caps 6-8 weeks after spawn is spread on to compost, whereas large woody brackets are not formed until the fungus has been growing through the tree for many years. The reason why some fungi grow beneath only one kind of tree is because the underground mycelium forms an association with the roots of the tree. This association, which is known as a mycorrhiza, is described more fully on page 74.

Amongst the saprophytic fungi are those which live only on fallen leaves, or conifer needles or pine cones (Fig. 4.5). The species which are confined to dung are known as coprophilous fungi (Fig. 6.1). Fungi which live as parasites on trees often attack one kind of tree or a group of related trees. For example, the beefsteak fungus (Plate 9) nearly always grows on oaks in Britain, while the cauliflower fungus (Plate 15) attacks conifers. But the destructive

Fig. 1.2 Yellow brain fungus (*Tremella mesenterica*) on birch. Available diffuse lighting using extension tubes. ×1

honey fungus (Plate 3) is not nearly so selective about which trees it attacks, and can be found on a variety of both broad-leaved and coniferous trees.

In the temperate regions, although some fungal fruiting bodies can be found throughout the year, late summer and early autumn is usually regarded as *the* fungus season. This is the time the majority of fungus forays (as fungus collecting excursions are called) occur and providing the season is not too dry, a wide variety of species should be available for photography. Joining a foray organized by mycologists, or a Natural History Society, is a good way to begin to get to know some of the distinctive features to look for. Generally, several pairs of eyes will be more productive than a single pair, but photographers are not always compatible with mycologists. I can ruefully still recall the time I saw in the viewfinder a hand appear and pluck the very fungus on which I had focused the camera as I lay prostrate on the ground!

The production of fruiting bodies is usually dependent on the availability of moisture. Many are ephemeral, remaining in good condition for a day or two only. Not many fungi can withstand frosts, and so the majority will cease fruiting once winter has set in. There are, however, a few species which can be found in mid-winter, including the jew's ear fungus (Plate 16), the velvet shank or winter fungus and the yellow brain fungus (Fig. 1.2). Some fungi, including morels and the St George's mushroom, appear only in spring; while even during dry summer spells fungi can still be found in permanently damp habitats such as swamps and boglands.

Woodlands – especially old woodlands with plenty of rotting trunks and stumps – are consistently rewarding sites for fungi. The techniques for finding woodland fungi depend on whether they are growing on the ground (page 40) or high up a tree (page 45).

Shape and form

In places, under favourable conditions of humidity, temperature and light, the mycelium forms dense aggregations of hyphae which develop into fruiting bodies. As these grow, they force their way up through the ground – even through tarmac or the bark of trees – and the spores so produced ensure the dispersal of the species.

Fungal fruiting bodies exist in a wide range of sizes and shapes, as well as colours. The illustrations in this book show only a few examples of their diversity of shape, colour and texture. In addition to the cap fungi, brackets and puff-balls described below, there

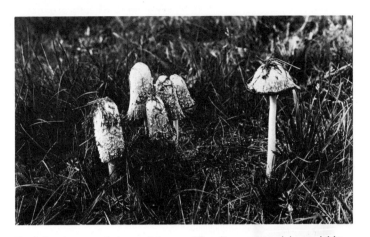

Fig. 1.3 A troop of shaggy ink caps (*Coprinus comatus*) in roadside verge. Note auto-digestion. Available light early in the morning

are cup fungi (Plate 6), morels, earth tongues (Fig. 2.5), fairy clubs (Plate 4), stinkhorns (Figs. 4.3, 5.1 and 6.2) and gelatinous jelly fungi (Plate 16 and Fig. 1.2).

Since no fungi contain the green pigment chlorophyll, green is a comparatively rare colour. Exceptions are the verdigris toadstool and the green staining fungus. The green of the verdigris toadstool is water soluble and so is easily washed out by rain, leaving a yellow cap. The green staining fungus stains the wood it infects bright green. This wood, known as 'green oak', was used in the manufacture of Tunbridge ware, which was a special form of inlay using minute strips of wood in a variety of natural colours. In the British climate, the tiny bright green cup-shaped fruiting bodies of the green staining fungus are not often found.

Cap fungi The most common form of the higher fungi is the typical toadstool, with a cylindrical stipe (stalk) and a dome-shaped cap. Within this general plan, there are many variations. The cap may be smooth, rough or scaly, dry or sticky; its overall shape may be convex, conical, flat, concave, cup or funnel-shaped, umbonate or umbilicate, and it may be attached eccentrically to the stipe. The relation between the gills and the stipe, also varies between species. Gills which are not attached to the stipe are free, while gills which run down the stipe are known as decurrent, and there is a range of intermediate states. These features, together

9

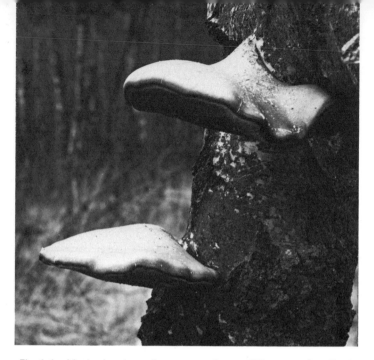

Fig. 1.4 Mature brackets of razor-strop fungus (*Piptoporus betulinus*) on birch. Long focus lens used to throw the background out of focus. × 0·25

with the colour of the cap, the stipe, as well as the gills or pores on the underside of the cap, are characters used to identify fungi in the field.

Bracket fungi do not have a separate stipe and cap. Instead they grow out horizontally forming brackets or shelves (Plate 9 and Fig. 1.4). Some may grow in tiers and others grow so thickly that they overlap and are known as imbricated. Most kinds of brackets grow on wood, often attacking living trees. In common with the boletes, many bracket fungi discharge their spores through tubes which open on the underside as pores; these often make interesting designs in close-up (Fig. 7.2).

Puff-balls are round or pear-shaped fungi which grow both in grasslands and in woods. When mature, the top splits open and the spores are released naturally in a cloud, by rain falling on the

fungus or artificially by squeezing the fruit body. The giant puff-ball (Fig. 2.6) is the largest ground fungus. Earth stars are closely related to puff-balls, but they have two quite distinct walls. The thicker, outer wall splits at maturity and bends back – often into a star pattern – to reveal the internal puff-ball shape (Plate 7). Like puff-balls, earth star spores are dispersed by raindrops (Fig. 4.1). In dry weather, the star of some species folds up again.

Identification

The microhabitat in which a fungus grows is often an important clue towards its identification, since many species only grow in association (often mycorrhizal) with one or a few species of plants. Leaves from overhead oak or beech trees or pine needles lying adjacent to a fungus in a photograph, can provide a useful re-minder of the type of woodland in which it was growing, as well as a natural scale.

How much time should be spent identifying a fungus in the field is debatable. There is no point in wasting valuable daylight hours trying to put a name to a fungus before photographing it. Similarly, apart from taking a purely pictorial photograph, there is little purpose in wasting film on photographing a specimen which cannot be identified later. Accurate identification of the subject is a fundamental requirement for a natural history photograph.

Field notes The naturalist photographer will soon appreciate that the solution lies somewhere between these two approaches. Make a provisional field identification if not before the photography, then immediately afterwards. Note, either in a hard-backed field notebook or pocket tape recorder, the habitat as well as the micro-habitat. Is it a solitary or a gregarious species? The coloration of the various parts should also be recorded, together with a note of any colour change which takes place on bruising or cutting fresh flesh. If the cap, stem or gills exude a milky juice, the fungus will be a milk-cap. In dry weather, however, it may not produce any 'milk'. Has the stem a ring or ring-like zone of fibres and has the base a cup or ridge around it? A small hand mirror, or better still a dentist's mirror, is ideal for viewing the underside of a small fungus growing close to the ground, to see whether it has gills or pores and what is their colour. A mirror will also show the way the gills are attached to the stem. It is also worth smelling a fungus, for some have very characteristic odours. Certain chemicals added to fresh fungi, produce dramatic colour changes in some species.

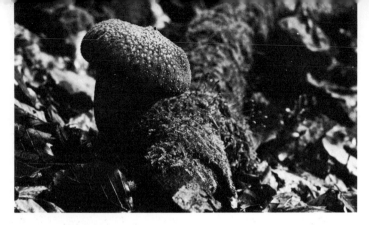

Fig. 1.5 Common puff-ball (*Lycoperdon perlatum*). Photographed against the light in a deciduous woodland using a close-up lens, camera on a ground spike. × 0·5

Details of the chemicals and the specific colour changes are given in advanced fungal keys.

Popular illustrated books for the identification of fungi include only a fraction of the total number of species, so that with their aid alone, it may be difficult or impossible to come to a reliable conclusion. If a specimen does not fit a description exactly, is it atypical in shape or colour, or (more likely) is it a species not illustrated? Many factors influence the growth form of fungi, which compared with flowering plants can be very variable. If there is any doubt about the identification down to species level, it is better to label a photograph by the generic name alone, than to guess at the specific name – just to add another tick to the check list.

Collection If an identification cannot be made with certainty in the field, then the fungus can be collected for detailed examination indoors. Since the underground mycelium will continue to grow and produce more fruiting bodies, collection of the entire fruiting body is not comparable with digging up a complete flowering plant, or even picking the flowers of some species. An open basket, such as a gardener's trug or a chip basket, is a suitable way of carrying collected fungi. Dig up the complete fruiting body with a fern trowel or a 'widger'. A strong knife may be needed to remove a tough bracket from a tree. If possible, collect specimens showing the various stages of development. So that the spores of one species do not land on other fungi, each type should be kept

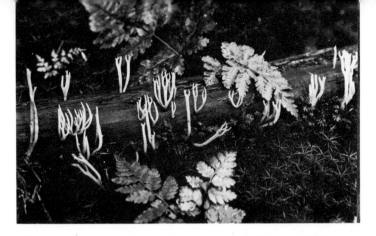

Fig. 1.6 Jelly antler fungus (*Calocera viscosa*) growing on fallen branch. Available diffuse lighting, with extension tubes, camera on ground spike. ×0·5

quite separate. Large cap or bracket fungi can be spaced out in the trug with their gills or pores uppermost, but smaller fungi should be placed in individual matchboxes, tins or tubes, or else wrapped in waxed paper. Containers with individual compartments, such as Perspex handyman's or fishing tackle boxes, are useful for separating different species. Examine your collection as soon as possible. After only a few hours in a centrally heated room fungi soon become shrivelled. They can be kept overnight if they are placed in an airtight container inside a refrigerator, or in a cold shed outside. Fungi which are collected intact on a branch and kept in a cool, moist atmosphere, will keep for several days or even weeks. Fungus beetles and flies breed inside fungi, so that many of the fleshy forms disintegrate within days of collection into a sodden mass of wriggling larvae.

In many cases, it is essential to make a spore print (page 86) to determine the colour of the spores. If the specimen cannot be identified by the collector, and it is important that it should be named, make as detailed notes as possible of its characters, including smell and taste (do not swallow even a small fragment), take a spore print and then dry the fungus in a warm current of air on a piece of fine wire-netting above a convector heater or a radiator. It can then be sent to a mycologist or taken to a museum or national herbarium for identification, since it is often impossible, even for an experienced mycologist, to identify a fungus from a photograph alone.

13

Fig. 2.1 Wrinkled club
(*Clavulina rugosa*)
taken by bouncing
flash off an overhead
flash umbrella.
Extension tubes. ×2

Fungi which grow on the ground are both easier to find and to photograph than those which grow on trees. The fruiting bodies of many fungi are in prime condition for at most only a day or two. It is therefore essential that once a fungus is found in good condition, it should be photographed immediately. Avoid postponement for even a day; for if the fungus does not start decomposing, it may become damaged by slugs or a squirrel.

Unless a record of specific feeding damage is required (Plate 21) the aim should be to photograph typical specimens in typical surroundings. Clearly, only when a particular fungus has been seen at least half a dozen times will it be possible to know whether it is the normal growth form in its typical habitat. This is where working in conjunction with an experienced mycologist or joining fungus forays can be such an asset.

Viewpoint

The viewpoint and the camera angle should be selected to suit each individual subject. At all costs try to avoid a stereotyped approach, such as using a tripod with a fixed amount of extension. Except for a very few conspicuously coloured species, the cap colour alone is insufficient for certain identification. Therefore specific characters such as the stipe and gills or pores should appear in a picture, in addition to the overall shape and colour of the entire fruiting body in its natural surroundings. A low viewpoint is often needed so that the gills or pores beneath the cap as well as a ring (if present) around the stipe are shown. The final decision must also take into account the way in which the fungus is to be illuminated.

In many photographs of cap fungi, one specimen will be seen uprooted and turned over so the underside is uppermost. Such photographs are useful for both lecturing and teaching, but must be classed purely in the scientific or record category. If every fungus picture includes an upturned specimen, the photographic techniques employed tend to lack variety and the results gain monotony and lack composition. Since the aim of this series of books is to combine accurate natural history recording with some degree of artistic appreciation, none of the photographs taken in the field in this book show an uprooted fungus. The use of a low viewpoint, or a wide angle lens to include more of the background than would be possible with a standard lens, can provide addi-

tional information and helpful clues in the photographs. Admittedly, most of the fungi included here are easily recognizable species. If a diagnostic feature cannot be shown without uprooting a specimen, expose a frame or two of the fungus as it was found *in situ*, before tipping it over.

The best viewpoint for illustrating the maximum number of features of most larger fungi is from the side; an overhead view looking down on to caps or tops of brackets is usually unsuitable. Exceptions are typically gregarious species, such as the sulphur tuft (Fig. 3.4) in which it may prove impossible to view it from the side, unless it is growing up over an upright log (Plate 20).

Whether a fungus is gregarious or solitary can be a valuable criterion for its identification. With solitary species it is important not to group them artificially for effect; nor should single specimens of a gregarious species be isolated.

Camera supports Many fungi grow in poorly lit habitats, and so some form of camera support is essential if good quality pictures are to be taken by means of available light. A rule of thumb guide for the slowest shutter speed which can be used for obtaining satisfactory hand-held pictures is the reciprocal of the focal length of the lens; for example, $1/_{50}$ or $1/_{60}$ second with a 50mm lens. In practice, this speed can be reduced by bracing the camera against a tree or resting it on the ground. However, once photographs taken using a tripod are compared with hand-held pictures, there is little doubt that it is worth using a tripod despite the extra weight to carry and time spent setting up the camera. Slower shutter speeds enable smaller apertures to be used and therefore increased depth of field to be gained, subject to the limitations imposed by reciprocity failure (page 24).

A tripod with short legs will be more useful than a conventional waist level tripod. For many ground species, a table-top tripod, a lowpod or a ground spike are ideal camera supports. A lowpod, which consists of a piece of wood on which a ball and socket head is attached, is useful only on flattish ground, whereas a ground spike will provide the ideal low-level support over a wide range of terrains. The spike itself is best made from a tapering piece of metal such as a tent peg, about 10cm long. If horizontal arms are added so that they radiate out from the shank at the broad end, they will provide additional stability in soft ground. A small ball-and-socket head is mounted on top of the spike. A ground spike obviously cannot be used on rocky ground or in soil with a high proportion of pebbles or boulders, otherwise it has few limitations.

On hard terrain, a useful alternative low-level camera support can be made by reversing the column on a large tripod, so that the head lies close to the ground. This is an ideal method for viewing directly down on to the ground (Plate 3).

Focusing the camera down at ground level will be easier if a waist level viewfinder is used, or alternatively a right angle viewfinder is attached to a fixed pentaprism.

Choice of lens

A standard lens is adequate for photographing the majority of fungi. For 35mm cameras this lens has a focal length of 50-55mm, whereas with 6×6cm (120 roll) cameras it is 80mm. Single lens reflex (SLR) cameras which have interchangeable lenses offer greater flexibility than cameras which have a fixed lens. Lenses for SLR cameras may have a fully automatic diaphragm (FAD) – also known as an auto-iris – or a preset diaphragm (PD). While FAD lenses are quicker to use, they are not essential for photographing fungi.

Macro lens Photographers who concentrate on close-up subjects will find that a macro lens is ideal for their work. Macro lenses have their own built-in extension, which permits focusing from infinity to 1:2 (half life size) or sometimes even closer. This is obviously a much quicker way of getting in close than by inserting separate extension tubes (page 29). The fact that the maximum aperture is usually smaller (f/3.5 on a Micro-Nikkor) than for a standard lens of the same focal length (e.g. f/2 or f/1.8) should not be a limiting factor to the nature photographer. Unlike the photojournalist who requires as 'fast' a lens as possible so that he can take an action photograph under poor lighting conditions, the aim should be to produce as sharp a definition as possible. Therefore either by using a slow shutter speed or by using an additional light source such as a flash, the lens can be stopped down to smaller apertures (to increase the depth of field) rather than opened up to the maximum aperture. The minimum aperture is also usually smaller on macro lenses (f/32 on the Micro-Nikkor) than on a standard lens.

Wide angle lens In addition to a standard or a macro lens, a wide angle lens which has a shorter focal length (35mm or 28mm on a 35mm format) than a standard lens, is useful for showing larger fungi in conjunction with their surrounding habitat. Plates 11 and 13 and Fig. 2.7 show just how effective this lens can be. The fungus

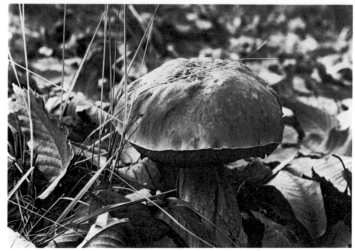

Fig. 2.2 Penny bun bolete or cepe (*Boletus aestivalis*) growing up amongst sweet chestnut leaves. Available lighting. ×0·3

will inevitably lie towards the front of the picture, but it need not always be placed centrally in the frame.

A long focus lens has the opposite effect and can be used to eliminate some undesirable feature in the background. It can also be used to isolate a fungus from its background (see below) or for photographing fungi growing on trees high off the ground.

Isolation from the background

Some fungi – such as the red and white spotted fly agarics (Plate 2) – will automatically stand out from their surroundings on both colour and monochrome film. Since fungi are rarely green, species which appear amongst grass and other green ground-covering plants show up clearly (Plates 10 and 18 and Fig. 2.5). However, many autumnal fungi are yellow or brown and therefore will appear much the same colour or tone as the surrounding autumnal foliage and fallen leaves. In this instance various techniques can be used to make the fungus stand out more clearly.

Very often the problem of deciding which specimen of many to photograph is solved by viewing each in turn through the camera and looking critically at the background colour (or tone), shadows and shapes. So often plant photography is a compromise

18

between selecting the best specimen and the most suitable background. The final solution of how to separate a fungus from its background may well determine the camera viewpoint or the choice of lens. In addition to the methods outlined below, natural light and shadow as well as flashlight (page 28) can be used to isolate a fungus from its surroundings.

'Gardening' Whatever technique is used to show a fungus to the best advantage, some degree of tidying up or 'gardening' is likely to be necessary. Successful 'gardening' is a skilful exercise of removing distracting stems, branches or leaves in front and behind the fungus, without appearing to have done so.

Resist any offers of help, since the tendency is usually to overdo the pruning. Tell-tale neatly cut ends of stems or branches must be avoided at all costs. Either pull up pieces of grass, or cut them with a knife behind a leaf or below ground level. Ends of rotting branches can be broken off and rubbed with soil to disguise the break. Living branches which cannot be lifted out of the field of view can be tied back with string or garden wire. With the exception of the perennial woody brackets, fungi are generally much easier to damage than flowering plants. A careless gesture with a hand or a tripod leg can so easily ruin a perfect specimen.

Branches lying well behind a fungus can still spoil a picture, even though they are out of focus. Bleached bracken and bramble stems are notorious examples, which can be overlooked so easily in the excitement of finding and focusing on a colourful fungus. Always remember to look critically in front and behind the subject. Are there any conflicting shapes, shadows or colours? On closer examination, an orange blob behind a clump of giant polypores turned out to be the fruiting body of the parasitic caterpillar fungus (Fig. 4.7); so I left it intact and altered the camera viewpoint instead.

Leaves, pine cones or acorns, provide natural scale objects, which should not be completely cleared away. Indeed, if the ground has been disturbed by animals or birds foraging, it may be necessary to *add* a few more leaves or moss lying close by, so as to cover a patch of bare soil. Resist the temptation of moving in objects, no matter how attractively coloured, from a different microhabitat. Fungi should never be transplanted either from one microhabitat to another, or worse still, into a completely different habitat. Books are full of such ecologically misleading pictures purporting to be taken 'in the wild'. The time can be better spent searching for another specimen in more photogenic surroundings.

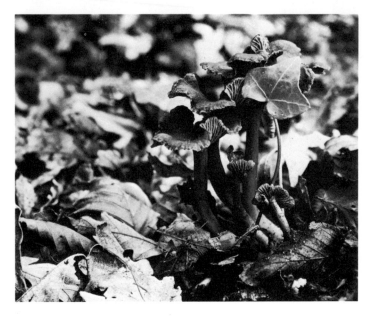

Fig. 2.3 Funnel chanterelles (*Cantharellus infundibuliformis*) with ivy
in deciduous woodland. Available lighting with large
reflector sheet. Extension tubes. × 0·5

Differential focus When a limited zone only appears in focus in a
photograph, it is known as being differentially focused. Record
photographs in general – including many nature photographs –
aim to get as much of the field of view as sharp as possible. How-
ever, greater impact can be gained by intentional use of differential
focus so that attention is concentrated on a foreground subject
while the background no longer conflicts or competes (or occa-
sionally *vice versa*).

When the background lies well behind the subject plane, it will
automatically appear out of focus in a close-up photograph (Plate
12). The extent of the depth of field (page 36) can be viewed
beforehand by stopping the lens down to the pre-selected aperture
or by depressing the preview button on FAD lenses. The depth of
field can be controlled either by altering the size of the aperture or
by changing the image size. If the background appears to conflict
with the fungus, try opening up a stop or two and altering the
speed accordingly.

A long focus lens, such as 135mm on a 35mm format, will also help to throw the background out of focus. Providing the fungus itself is sharply defined, a different toned or coloured background will harmonize with it as a natural backcloth.

Artificial backgrounds Inserting a board or piece of paper behind a fungus is very much a short-cut method of isolating it. With thought and patience it should always be possible to utilize one of the methods outlined above, rather than to fall back on an artificial prop. Even if a pale uni-toned green, blue or brown board is used, it will appear totally unnatural and it may well create shadow problems if it is placed too close behind the subject. Such a background eliminates any hint of the surroundings, and apart from the conservational aspect (which, as mentioned on page 12, is not obviously applicable to fungi), there seems little point in photographing any widespread fungi growing *in situ* by this method. Rarities can be classed as an exception to the rule. Then, if colour photographs are to be used as the basis for artist's reference at a later date, a completely plain grey or buff background, with an additional metric scale, will be invaluable.

Lighting

Lighting is basic to the success of a photograph; no less one of a fungus. A totally different atmosphere can be induced by substituting diffuse sunlight for direct flashlight. While the shape of the fungus relative to its surroundings will have a direct bearing on the camera viewpoint, the type and direction of the lighting should also be an influencing factor.

Available The majority of fungi can be photographed in the field using daylight. The only limitations will be when working with slow speed colour filmstock on windy days, in dark locations, or when using bellows for magnifications of greater than life size.

A slightly overcast day produces diffuse lighting which is ideal for photographing fungi, since no harsh shadows will be cast. Direct sunlight can provide added sparkle after a shower (Plate 20), but it more often results in a distracting mosaic of highly contrasting light and shade, which is beyond the latitude of colour films. Sunlight streaming through overhead leaves can produce colour casts to which the human eye adapts, but which becomes misleadingly recorded on colour film.

The angle at which direct sunlight falls on a fungus also influences the modelling as well as the overall effect. If details of the

stipe are obscured by the shadow cast by the cap, use a board covered with aluminium cooking foil, a white handkerchief or board to reflect back some of the light to help fill in the shadow. The survival blanket sold for campers and hikers makes a very effective large, but lightweight, light bouncer. The re-usable survival blankets made of PVC sheeting and coated on one side with aluminium can also be used for kneeling on damp ground, for covering the camera set-up on a tripod during intermittent showers, and even for carrying specimens back to the car! Back lighting is always dramatic, but may not adequately show all essential features, unless a reflector or flash is used to fill in some frontal detail. It is most successful when used for simple translucent forms such as the fairy clubs (Plate 4). When photographing against the light, use a lens hood to reduce the chance of flare caused by light falling directly onto the front lens element.

Transmitted light, which passes through a subject, is always effective for translucent spring or autumnal leaves. Figure 3.1 shows the slimy beech cap fungus photographed by transmitted light. Usually growing high up on beech trees, this specimen was found growing from a fallen branch. The underside of the fungus was taken by lying on the ground and looking up towards the sky. Although it is a more striking picture than Fig. 3.2, it is botanically misleading. The dark lines which look like the inter-gill spaces are, in fact, the gills themselves which are less translucent than the spaces. This picture illustrates the conflict between the need to represent the subject accurately in natural history photographs and the desire for some aesthetic appeal.

Time exposures In poorly lit locations, fungi can be photographed on monochrome films using long exposures of more than 1 second. A firm camera support – either a tripod or a ground spike – and a cable release, are essential for a successful time exposure. Set the shutter to the B setting and to avoid any vibration from the camera itself, either lock up the mirror or use the delayed action mechanism. The shutter will remain open so long as pressure is kept on the shutter release – if necessary by using a locking cable release. Some cameras have a T setting, which is more suitable for especially long exposures of many seconds or even minutes, since an initial pressure on the release will open the shutter and a second one will close it. When working in a very dark wood it will be impossible to measure the light without a very sensitive meter, such as the Lunasix. With monochrome film, a series of bracketed exposures can be taken, each one doubling the length of time the shutter remains

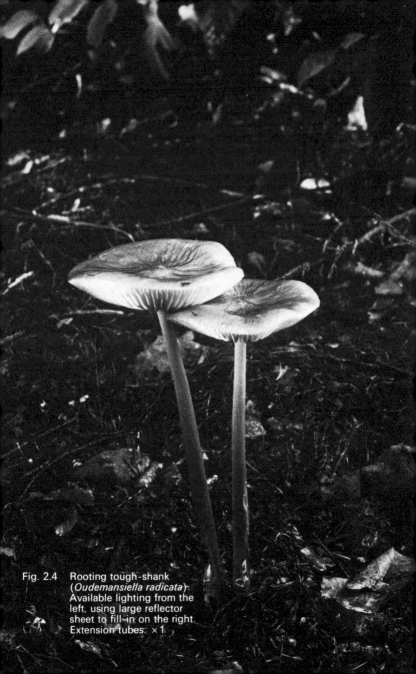

Fig. 2.4 Rooting tough-shank (*Oudemansiella radicata*). Available lighting from the left, using large reflector sheet to fill-in on the right. Extension tubes. ×1

open. Figure 2.7 was taken in this way late in the day in a beech-wood, and I found that there was very little difference between my initial exposure of 5 seconds and my final one of over 5 minutes, taken 15 minutes later. The light was obviously falling off in proportion to my exposure increase!

Focusing the camera also becomes a problem in a dark wood. For close-ups, a wide angled torch is useful. For more distant photographs, estimate the distance from the nearest to the furthest object you require in focus. Select the aperture which includes these distances on the depth of field scale.

Long exposures should generally be avoided with colour film-stock, since a shift in the colour balance takes place. The most noticeable change is in the greens, especially grass which takes on a distinctly bluish tinge. Wet leaves will also tend to show a similar colour cast. By trial and error the slowest shutter speed which is acceptable for a given film-stock can be determined. In practice, I have found that providing there are no green objects in the field of view, I can get satisfactory exposures up to 1 second with the notoriously slow, but virtually grainless Kodachrome II (25 ASA). Otherwise, I would not normally use exposures in excess of $^1/_8$–$^1/_4$ second with colour material. Also, when exposures of longer than 1 second are used, the film speed of the emulsion becomes reduced so that an increase in the exposure time must be given. This breakdown in the reciprocal relationship between time and intensity, at long and also short (less than $^1/_{1000}$ second) shutter speeds is known as reciprocity failure.

The technique of double rating a film is most often applied to action pictures of animals, but it can also be useful for photographing fungi in colour on a windy day, without flash. It is important to determine that a double-rated colour film can be processed, *before* setting the ASA or DIN rating on the light meter or on a camera with through-the-lens (TTL) metering, to double the film speed given on the film pack (64 ASA Ektachrome-X becomes re-rated to 128 ASA). Remember to double rate the film speed for *the whole film* and to instruct the processing laboratory accordingly. Providing the camera is protected with an umbrella, exposures can be made during rain.

Flashlight should be used sparingly to photograph fungi, and not always used to provide frontal lighting. The most obvious use for flash is for boosting the lighting in dark locations; but it can also be used for increasing the depth of field, isolating the subject from its background and for arresting movement on a windy day.

24

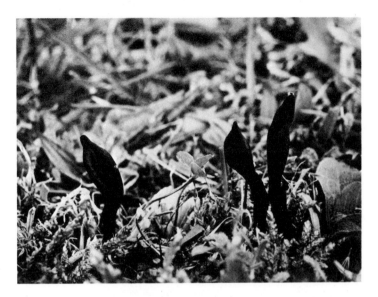

Fig. 2.5 Earth tongues (*Geoglossum cookeianum*) contrast in shape and tone with the grassland. Available lighting, with extension tubes, camera on ground spike. × 1

Using the flash mounted directly on to the camera is far from ideal, since it produces little modelling to the fungus. Before using a single direct flash, consider carefully where the shadow will fall. The majority of such flashlit pictures – particularly of cap fungi – are ruined by the harsh cap shadow. As for sunlight, the use of a reflector or a light bouncer will help fill in the shadow area. Alternatively, a second flash can be used to fill in. Both flashes can be mounted on to two angle brackets on the camera and the whole assembly used as a single unit. A double adapter is used for connecting the two flash leads to the camera flash socket. When a flash is used remote from the camera, it can be held in position by attaching it to a spike, a monopod, or a smaller tripod by means of a flash shoe.

Front-lit flash pictures often show little detail of the gills or pores of white or pastel-coloured fungi, because of the harshness of the lighting. However, with care and thought, flash can be used to advantage. Indirect lighting, produced by bouncing the flash off the inner reflective surface of a flash umbrella will give softer edged shadows (Figs. 2.1 and 5.3).

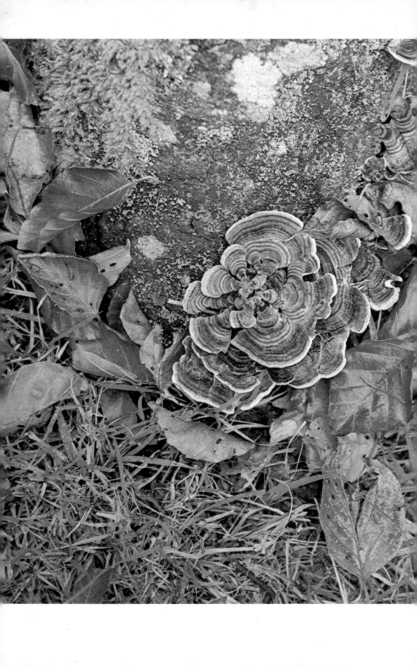

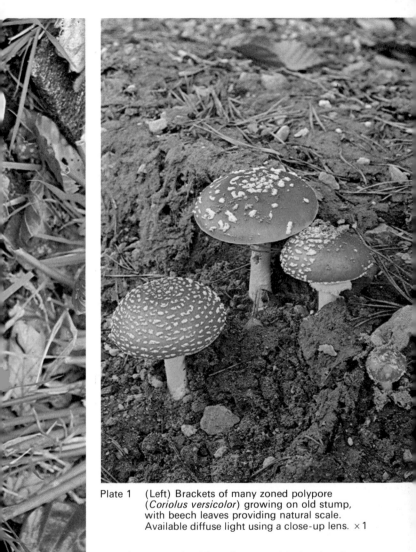

Plate 1 (Left) Brackets of many zoned polypore
(*Coriolus versicolor*) growing on old stump,
with beech leaves providing natural scale.
Available diffuse light using a close-up lens. ×1

Plate 2 Fly agarics (*Amanita muscaria*) showing the
white remnants of the universal veil on the
scarlet caps. Available diffuse lighting.

If fungi growing on the ground are photographed by flashlight, they often appear in the photograph starkly lit against a dark background. This is the result of the light intensity falling off with the square of the distance from the flash. So that if the subject is a metre away from the flash and the background 2m beyond, the ratio of the light falling on the subject to that falling on the background is $1^2 : 3^2$ or $1 : 9$. The ratio can be improved but at the expense of losing light intensity, by moving the flash away from the subject. At a subject distance of 3m, and so a background distance of 5m, the ratio becomes $3^2 : 5^2$ or approximately $1 : 2.5$. The background will still be darker than the subject, but the overall effect will not be so stark.

Ways of overcoming the nocturnal appearance of daytime flash pictures with distant backgrounds, are to insert some authentic foliage close behind the subject, to use a second flash to illuminate the background, or to balance the flashlight with the sunlight (see below). Fungi growing flush with the ground or a trunk will not present the same problems when using flashlight.

The correct exposure when using flash for close-ups will have to be determined from a trial run of exposures. Take a series of 'bracketed' exposures (by varying the aperture) of a fungus with an average contrast, making sure to keep the filmstock, the magnification and the flash-to-subject distance constant. Adjustments can then be made for subjects which are larger or smaller and paler or darker. If the flash is attached to an angle bracket on the camera, it will automatically be brought nearer to the subject – as the camera is moved in closer. This compensates for a reduction in the light intensity as the amount of extension is increased, and in practice, it may be found that an identical aperture can be used over a range of magnifications.

With electronic flash, always use the X synchronization socket on the camera. A diaphragm or leaf shutter has the advantage of synchronizing with flash at any speed; whereas a focal plane shutter will synchronize only when the entire frame is exposed at once. On some models this is $^1/_{30}$ second, but most modern cameras synchronize at $^1/_{60}$ or even $^1/_{125}$ second. If the flash is no longer used as the major light source, so that it does not over-ride the available light, then all the advantages of flash can be gained, together with an illuminated background. One method – known as *synchro-sunlight* – is a balanced combination of sunlight and flashlight, whereby the flash can be used to fill in the shadows. Take the daylight exposure and set the shutter speed and aperture accordingly. By dividing the guide number of the flash by the

selected aperture, the correct flash-to-subject distance which will provide an intensity equal to the daylight, is found. Multiply this distance by $1^1/_2$–2 to get an acceptable combination whereby the flash fills in the shadows without completely overriding them. The balance between daylight and fill in flash can be varied either by altering the shutter speed (this affects the daylight) or the flash-to-subject distance (this affects the flash intensity).

Getting in close

Close-up photography begins at the shortest camera-to-subject distance which a standard (not a macro) lens can be focused without any accessory, through to life size reproductions (1:1). Where magnifications of greater than life size are recorded on the film, the term macrophotography should be used. Examples of original macrophotographs included here have the letter M after their magnification.

All the photographs in this book have been taken using SLR cameras with interchangeable lenses. The lens and accessory which was selected for use is specified in most captions. Since a sharply defined subject is essential in a close-up, accurate focusing is vitally important. An SLR camera is therefore preferable, but by no means essential. Non-reflex and TLR cameras can also be used for photographing static subjects, such as fungi, in close-up. Both types of camera, however, suffer from the problem of parallax error, which must be compensated for in close-ups. Also, the camera-to-subject distance must be accurately measured with non-reflex cameras.

Close-up lenses The macro lens described on page 17, is *the* lens for close-up photography. A much cheaper way of getting in close is to use a close-up lens attached to the front of the camera lens. These supplementary lenses are both convenient to use and light in weight, but unless small apertures are used there may be an overall loss in definition, especially with cheap close-up lenses. When using a fixed lens camera, a close-up lens is the only way to get in close. Compared with extension tubes and bellows, the increase in magnification is limited, but since there is no significant light loss, no exposure correction need be made. The power of a close-up lens is usually quoted in dioptres ($+1$, $+2$ and $+3$), a $+2$ dioptre lens magnifying twice as much as a $+1$ dioptre lens.

Extension tubes and bellows Cameras with interchangeable lenses can have either extension tubes or bellows inserted between the lens and the camera body. Both these accessories increase the

29

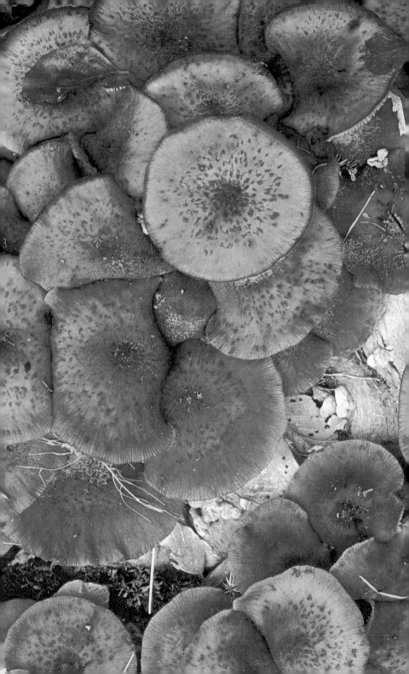

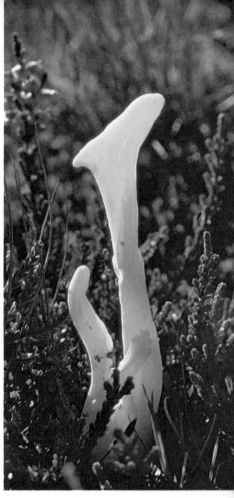

Plate 3 (Left) Mature fruiting bodies of honey fungus (*Armillaria mellea*) crowded on old stump. Notice white spores. Available diffuse lighting with extension tubes. Camera on reversed tripod head. ×1

Plate 4 A fairy club on heathland. Photographed against the light with a macro lens. Camera on ground spike. ×3

distance through which light has to travel to reach the film plane, so an additional exposure increase must be made (see below). Of the two, extension tubes are cheaper. They can be broken down into predetermined lengths, which simplifies the calculation for exposure increase without TTL metering. However, since most bellows units now have the distance (in mm or cm) engraved throughout the length of the track, this can no longer be used as an argument against them. Only a few bellows, whereas most extension tubes, close down to the preselected aperture as the shutter is released. The main advantage of bellows is that like the macro lens, they provide continuous focusing and alteration of the reproduction scale. They also enable magnifications of greater than 1:1 to be made with a 50mm or a shorter focal length lens. At the other end of the scale, the minimum bellows extension may prove too great for certain subjects. In which case, either the smallest extension ring or a close-up lens will have to be used instead.

Exposure Determination of the correct exposure with close-ups so often presents a problem; and yet, providing a few basic facts are grasped, it is not difficult. Only when exposure determination ceases to be a problem can all thought and effort go into composing the picture. Instructions supplied with extension tubes or bellows are often packed with confusing formulae and tables.

The amount of exposure increase will vary depending on the amount of the extension (in mm)used and also the focal length of the lens, as given below:

$$\begin{array}{l}\text{aperture}\\\text{(f number)}\\\text{to be used}\end{array} = \begin{array}{l}\text{aperture taken}\\\text{from light}\\\text{meter reading}\end{array} \times \frac{\text{focal length of lens}}{\text{focal length of lens} + \text{extension}}$$

Therefore when a complete set of extension tubes (50mm) is used with a 50mm lens on a 35mm camera, the distance between the lens and the film plane is doubled from 50 to 100mm. In effect, the amount of light reaching the film is quartered and therefore the aperture must be opened up by two full stops (e.g. from f/11 to f/5.6 or from f/8 to f/4).

Exposure determination for close-ups is generally quick and easy on cameras which have a built-in TTL metering system; but there are a few pitfalls worth noting. Models which utilize a 'full screen' metering system will have to have allowances made for a subject which is lighter or darker than the overall field of view. When photographing a specific subject within the field of view, a 'spot' meter will be more accurate. But, since TTL meters measure light reflected from the subject, they will not give an accurate

32

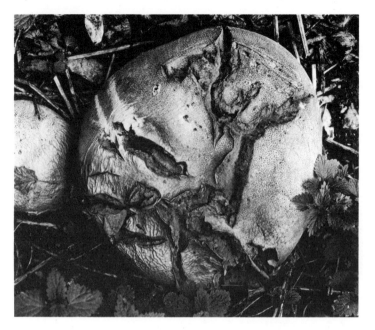

Fig. 2.6 Mature giant puff-ball (*Langermannia gigantea*) taken from overhead with camera on tripod, to show cracked surface that allows the spores to escape.

exposure for a small pale subject against a dark background, or *vice versa*. A more accurate method is to measure on a separate light meter the incident light falling on the subject. A quick method of determining the exposure when taking a rim lit subject against the light is to move round so as to meter the light reflected off the whole subject. This reading will then be acceptable for the rim lit region.

In spite of sceptics who remain loyal to their separate light meters, TTL metering is quick, and providing it is intelligently used, should give good results under most circumstances. TTL metering is the only way of ensuring an accurate last-second check on exposure when the ambient light is constantly changing; for instance, on windy days when the sun can be out one moment and it is overcast the next. Under such conditions, by the time a reading has been transferred from a separate meter to the camera, it may well have changed.

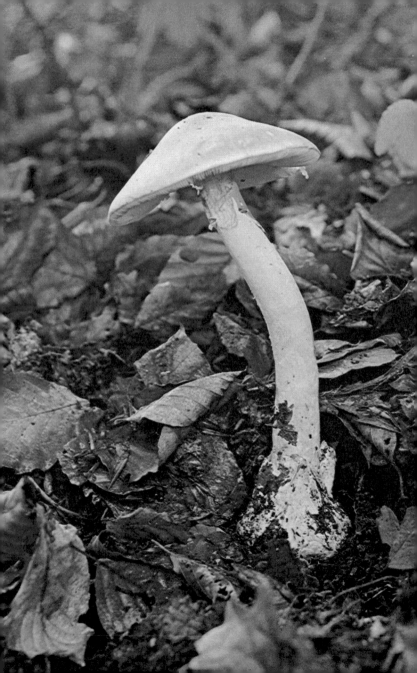

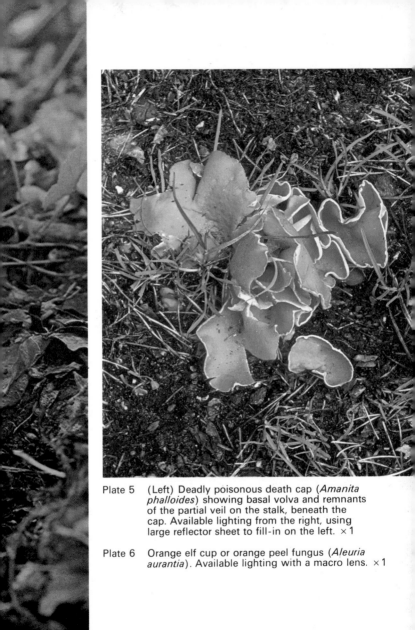

Plate 5 (Left) Deadly poisonous death cap (*Amanita
 phalloides*) showing basal volva and remnants
 of the partial veil on the stalk, beneath the
 cap. Available lighting from the right, using
 large reflector sheet to fill-in on the left. × 1

Plate 6 Orange elf cup or orange peel fungus (*Aleuria
 aurantia*). Available lighting with a macro lens. × 1

Depth of field is the zone of sharp focus in front of and behind the plane on which a lens is focused. When using wide apertures or a long focus lens, only a limited zone is sharp. By stopping down the diaphragm or by using a shorter focal length lens from the same camera position, the depth of field will increase on both sides of the plane of focus, but twice as much beyond it as in front. The actual depth of field for a given aperture can either be read from a scale on the lens (only macro lenses will have depth of field scales for close-ups), or be seen by direct viewing through an SLR camera. The depth of field can also be increased by *decreasing* the magnification by either moving further away or by using a wide angle lens.

Close-up photography makes an attempt to show all planes of the subject in sharp focus, whilst separating it from its background either by lighting techniques or by differential focus. The aim is therefore generally to work at smaller (f/16 or f/11) rather than larger (f/4 or f/5.6) apertures. At magnifications of 1:1 (life size) the depth of field is almost the same behind and in front of the plane of focus.

Habitats

So much for the techniques in general; now briefly to consider some of the different places where fungi can be found growing on the ground.

Grasslands Photography of fungi on lawns, meadows and pastures presents problems which may not be immediately apparent. The one advantage about these situations is that there is nearly always plenty of available light. The background, however, will tend to be rather monotonous, unless a wide angle lens is used. Also, large expanses of grassland are more exposed to wind than woodlands.

When a low viewpoint is used, the edge of a lawn, a flower bed or a hedge can produce a distracting straight line cutting across behind the fungus. Even for close-up pictures, light striking criss-crossing blades of grass can be very distracting. Grassland species are generally smaller than woodland species, and sometimes a correlation can be found between the length of the stipe and the height of the grass. If the grass stems obscure an important anatomical detail, careful 'gardening' will be needed. Agarics which grow on pastures and meadows include many *Hygrophorus* species, some of which have brightly coloured red, yellow or orange caps. Other examples of grassland fungi can be seen in Figs. 1.3 and 2.5.

36

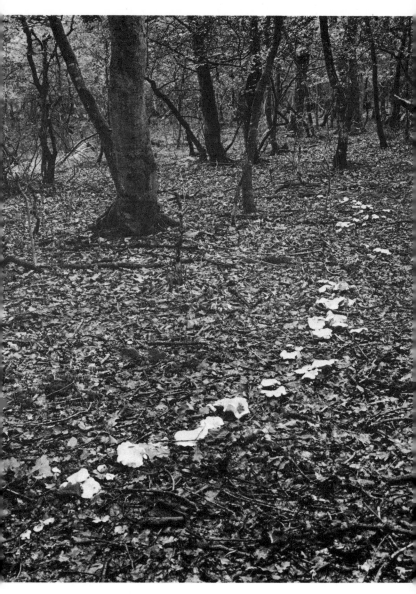

Fig. 2.7 Incomplete ring of hedgehog fungi (*Hydnum repandum*).
Taken with a wide angle lens in failing evening light using a
time exposure of 40 seconds.

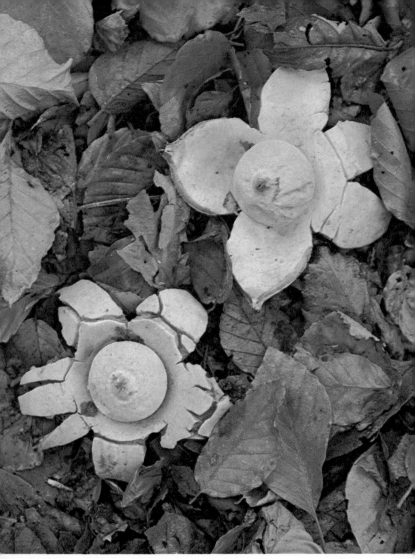

Plate 7 Earth stars (*Geastrum triplex*) amongst beech leaves. Available diffuse lighting using extension tubes and camera mounted on reversed tripod head. × 1

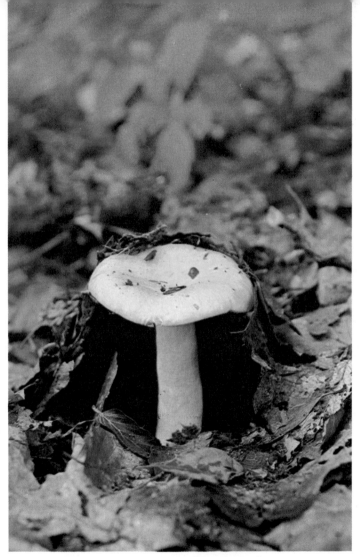

Plate 8 Common yellow russula (*Russula ochroleuca*) pushing up through the leaf litter. Available diffuse lighting using extension tubes. Camera on ground spike.

Fig. 2.8 Earth fan (*Thelephora terrestris*) in pinewood. Available
lighting with large reflector sheet. Camera on reversed
tripod.

Woodlands In woodlands, fungi take advantage of every micro-
habitat: the soil, leaves, mosses, trees, stumps, logs and twigs.
They play a fundamental role in accelerating the decay of organic
material in a woodland. In a mature wood, more fungi will be
found round the edge, along the rides and in clearings, rather than
beneath trees. Old deciduous woodlands – especially oak and
beech – are always particularly rewarding places to look for fungi.
As trees fall to the ground they open up the overhead canopy, as
well as provide food for fungi at ground level.

Many species grow in a variety of woodlands, while others are
restricted to one kind. For instance, some of the coniferous wood-
land fungi never grow in deciduous woods. Small ground species
are found by short-range critical viewing, rather than by casual
sweeping glances. Very often a species will be found quite by

chance whilst stopping to photograph a more conspicuous fungus. The main problem of photographing fungi in woodlands is the available light either being too dappled (page 49) or too low (page 22).

Burnt ground In common with certain mosses and flowering plants, some fungi are specifically colonizers of ground which has been burnt. These bonfire fungi do not have to compete with many other species. Areas where foresters burn trimmings are worth noting for these fungi; for instance, brown funnel polypores frequently grow on burnt ground.

Dung has its own specialized fungal flora, which utilizes this rich source of organic matter. Since droppings are soon broken down, coprophilous fungi do not have a persistent mycelium, and therefore grow up directly from spores. These spores are eaten with the grass and are passed out undigested with the dung, so some species appear very soon after it has been voided. Dung will produce a crop of fungi during any month of the year. The succession can be observed by collecting rabbit or sheep pellets and incubating them on damp blotting paper in a covered petri dish or a sandwich box in a warm place. The specimen illustrated in Fig. 6.1 was cultured in this way on a rabbit dropping.

Subterranean Some fungi spend their entire life history underground. All subterranean fungi have rounded fruit bodies, the best known being the truffles. In Europe, pigs are used to track them down by their smell. Truffles are a comparative rarity in England, but in some southern English counties, notably Wiltshire, special truffle hunting dogs were once used for finding them. Without the aid of pigs or dogs, truffles are difficult to track down. Other clues to look for are cracks in the ground and columns of flies rising up from the underground truffle in which they breed. Subterranean fungi will obviously have to be dug out to be photographed.

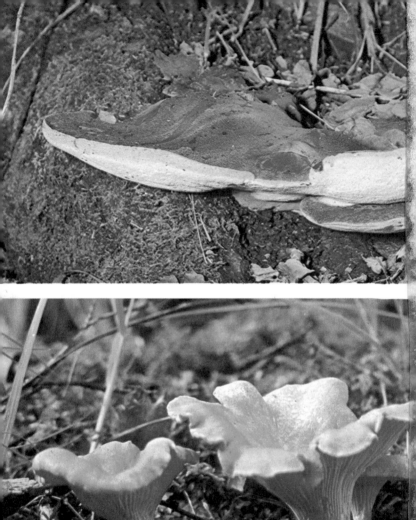
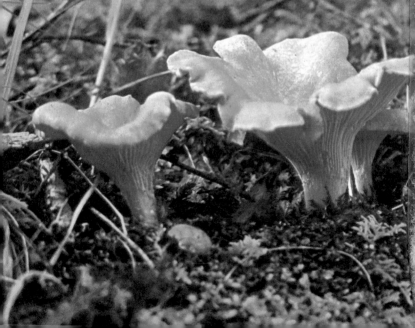

Plate 9 Beefsteak fungus (*Fistulina hepatica*) growing on living oak tree, showing coloration of both upper and lower surfaces of the brackets. Direct flashlight. ×0·5

Plate 10 Chanterelles (*Cantharellus cibarius*) showing false gills on underside. Available diffuse lighting using extension tubes. ×1·25

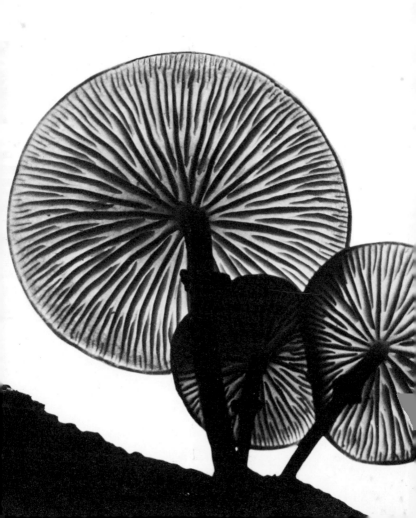

Fig. 3.1 Slimy beech caps (*Oudemansiella mucida*) growing from fallen beech branch. Photographed using a standard lens with diffuse transmitted lighting. ×2

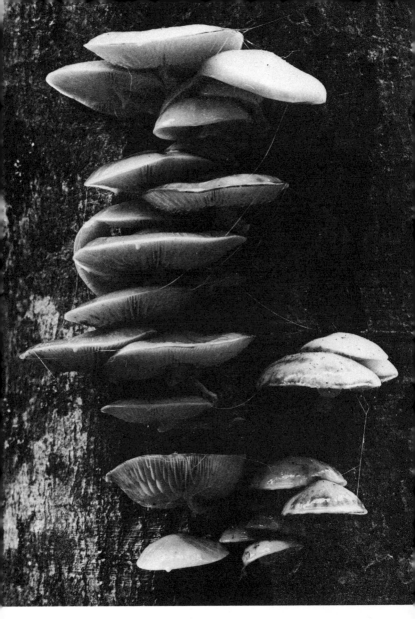

Fig. 3.2 Slimy beech caps (*Oudemansiella mucida*) with cobwebs, showing short intermediate gills. Available lighting using a long focus lens. ×1

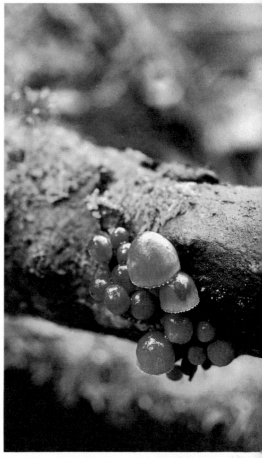

Plate 11 (Left) Spotted tough shanks
 (*Collybia maculata*) growing in
 a pine wood. Photographed
 from a low viewpoint, with the
 camera on a ground spike, and
 a wide angle lens.

Plate 12 Bleeding mycena (*Mycena
 haematopus*) on fallen branch
 showing characteristic 'bleeding'
 produced by damage to cap.
 Macro lens. Available lighting
 using large reflector sheet to
 fill-in. ×1·5

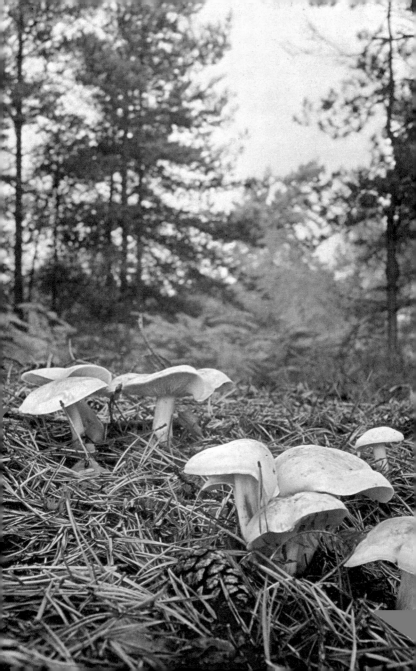

Fungi which grow on trees include both parasitic forms which attack living trees and saprophytes which feed on the dead wood of standing and fallen trees.

Standing trees

The living wood of trees is the so-called soft wood, which lies immediately beneath the bark. The heartwood in the centre is lifeless. Most fungi which attack trees are wound parasites, which gain entry via damaged bark. When branches are broken – either naturally by gales and snow, or by tree surgeons – the exposed ends are susceptible to fungal attack. The old practice of coppicing and pollarding trees provided large entry wounds for fungi, hence the widespread use of fungicides in modern forestry.

Many parasitic fungi confine themselves to a single tree species: the razor-strop fungus on birch, slimy beech caps on beech (Figs. 3.1 and 3.2) and jew's ear fungus on elder (Plate 16).

Locating fungi Large bracket fungi growing on tree trunks can be spotted by long range viewing – at the same time making sure not to trample any choice ground species underfoot! Binoculars are also useful for scanning trunks and branches some distance from the ground. While some decay fungi can be found growing at any height above the ground, others consistently appear at a particular height. Hence foresters divide decay fungi into 'top rots', 'butt rots' and 'trunk rots'.

It is worthwhile walking right round the base of old standing trees searching for fungi growing out near ground level, and peering into hollow trunks. Fungi growing on the stumps of felled trees are much more conspicuous (Plate 3).

Photography Most of the techniques already described for photographing fungi at ground level, can be applied equally well to fungi growing at the base of trees. However, a few additional points are worth mentioning. Try to show some evidence of the host tree, either by including fallen leaves, or its typical bark pattern, or part of a living leafy branch. Most species growing out through the bark of standing trees produce either single large fruiting bodies or clusters of small ones, so that depth of field should be no problem – even when using available lighting – providing a tripod is used.

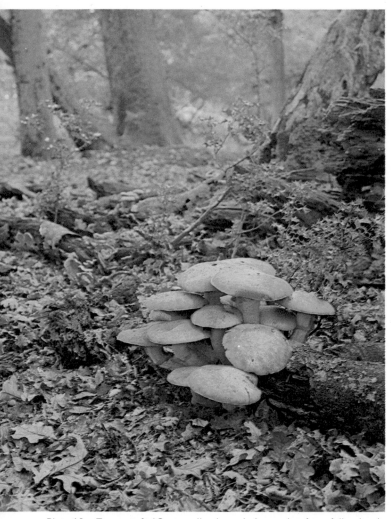

Plate 13 Tawny tuft (*Gymnopilus junonius*) growing from fallen log in deciduous woodland. Wide angle lens and available lighting.

The best viewpoint for photographing encrusting fungi as well as gregarious species on the flat top of a stump, is from directly overhead. A tripod can be converted into an overhead camera support by reversing the head, but beware of the legs casting shadows across the subject on a sunny day. Long term photo-sequences can be made of the progressive colonization and decay of a tree stump by fungi.

Quite different techniques may have to be used for photographing fungi growing high up trees. A long focus lens may initially seem to be the obvious answer, but when looking straight up from ground level only the underside of the fungus will show. A better viewpoint will be gained by climbing a neighbouring tree and using a long lens on much the same level as the fungus, steadying the camera by bracing it against the trunk. If there is no suitable tree, photographing from the top of a stepladder can help to improve the perspective. Alternatively, the tree bicycle used by foresters to collect seed from high branches can be used by a photographer with a head for heights.

On a sunny day, views looking up through the canopy will often have a distracting mosaic of light and shade as background. Check the appearance of the background by stopping down to the pre-selected aperture, and see if the effect is improved by opening up or closing down the aperture.

Bracket fungi are generally more durable than cap fungi and so they can be photographed over a longer period. Young brackets are soft, but as the larger perennial forms mature, they become tough and even woody. The common ganoderma is one such species which can be found throughout the year, and once hardened, the brackets can support a man's weight. The majority of bracket fungi appear in the autumn, but some, including the spectacular sulphur polypore (on the jacket) appear in the summer.

The colour of the upper surface of bracket fungi will not show if too low a viewpoint is used. Also, care must be taken when using flashlight to illuminate both surfaces equally. If the flash is held at too high an angle the edge of the bracket will cast a shadow on the underside.

To the untrained eye, brackets which grow out at right angles from a trunk, do not have a definite top or bottom. Consequently photographs of bracket fungi are frequently reproduced upside down in books. From my experience, writing *top* on the cardboard mount or on the protective sleeving of the transparency is of little use – unless the designer happens to take note before he re-

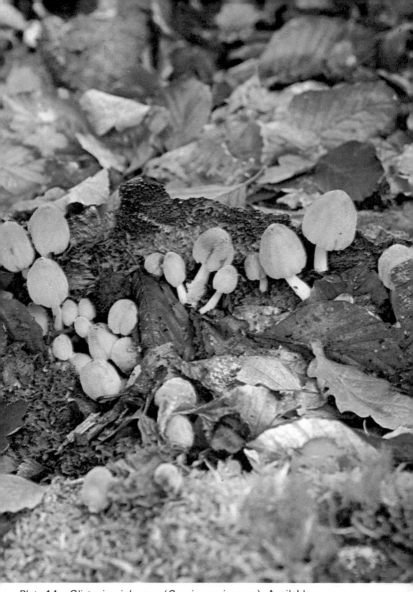

Plate 14 Glistening ink caps (*Coprinus micaceus*). Available diffuse light using extension tubes. ×1

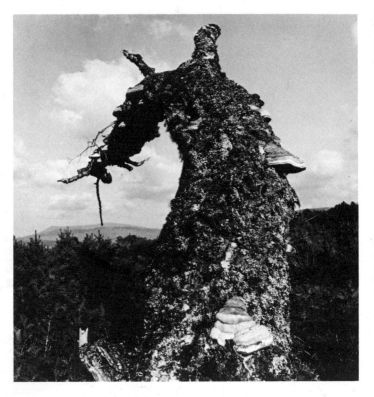

Fig. 3.3 Tinder fungus (*Fomes fomentarius*) growing on old lichen-encrusted birch tree in the Scottish Highlands. Sunlight.

moves the transparency. Even then, the printer can so easily turn the block through 180° and if time is short it can be missed in the proof-checking.

Perennial brackets can be photographed during any month of the year; but the time during which the spores are produced, is limited. So many chocolate brown spores are produced by the common ganoderma during late summer that they colour the surrounding vegetation. The newly formed pores of ganoderma are sensitive to bruising and their surface can be written or drawn on with a needle or a biro. Reddish-brown marks are produced which will be retained for years. Fungus paintings were made in this way in North America early in this century.

Fallen trees

Piles of rotting branches are an oasis for not only fungi, but also mosses and liverworts. In one day, I found over 15 species of fungi on one such pile and a succession of new species continued to appear for several weeks. Many similar piles had been completely destroyed – not by woodland animals – but by over-zealous entomologists searching for larvae and pupae. Here is an instance when two scientific disciplines have conflicting interests within a single microhabitat and conservation is a dead duck!

When working amongst a pile of rotting branches, care must be taken not to move suddenly backwards nor to lean against any of the crumbling branches: they can so easily break and cause damage to other fungi. But, if a branch is in shade, it can easily be moved into a more photogenic position. Old stumps and logs retain moisture better than soil, so they are good fungi sites – even in a dry season.

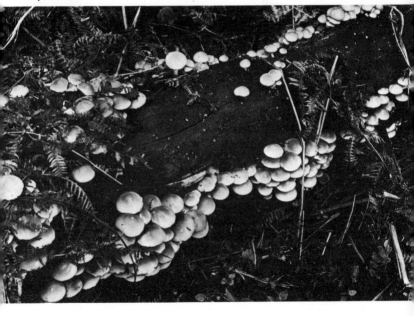

Fig. 3.4 Sulphur tuft (*Hypholoma fasciculare*), a gregarious fungus growing from fallen log amongst dead bracken. Available diffuse lighting.

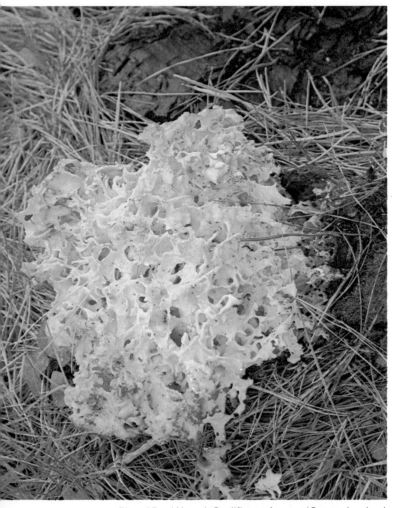

Plate 15 (Above) Cauliflower fungus (*Sparassis crispa*) on base of pine tree, with needles providing natural scale. Available diffuse light using a close-up lens.

Plate 16 Jew's ear fungus (*Hirneola auricula-judae*) growing on elder. Available diffuse light. ×1·5

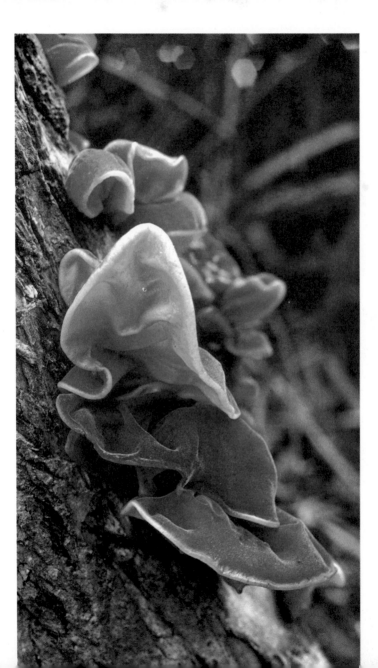

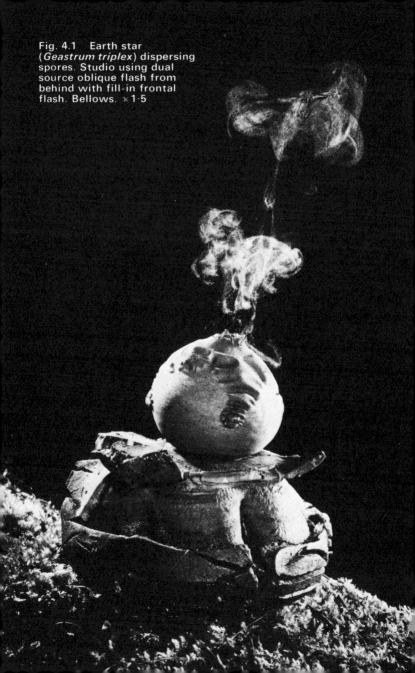

Fig. 4.1 Earth star (*Geastrum triplex*) dispersing spores. Studio using dual source oblique flash from behind with fill-in frontal flash. Bellows. × 1·5

The most noticeable part of a fungus on which all attention has so far been focused is the fruiting body. Its function is the production of microscopic spores. The way in which the spores are produced, their size, shape and colour are often important factors in specific identification. The spores germinate to form a branching web of fine strands called hyphae. This actively growing and feeding part of the fungus is known as the mycelium (Fig. 4.2). It penetrates through the substrate, whether it be soil, rotting organic matter or living animal or plant tissue. The mushroom 'spawn' which is sold for cultivating edible mushrooms, is a portion of this mycelium.

In some species, the thin hyphal threads grow together to form thick strands known as rhizomorphs. Black rhizomorphs – the thickness of boot laces – can be found running beneath the bark of trees infected with the honey fungus (Plate 3). Once the mycelium has reached a large enough size and conditions become suitable, it produces fruiting bodies. Clearly, the most effective stage during which fungi become dispersed, is as spores.

Spore dispersal

Production of spores is directly related to the temperature and humidity, as well as the available food. Most fungi have no special means of dispersal, the ripe spores being liberated via the gill slits or pores and then wafted around in the air currents. Individual spores are microscopic, but copious production by large brackets, colour the surrounding vegetation to such an extent that they clearly show in a colour photograph.

In certain species, spore dispersal has become highly specialized. When ink caps mature, the spores are liberated into the air and the cap margin dissolves into a fluid as 'auto-digestion' takes place. Ink caps are typically gregarious fungi – shaggy ink caps grow in distinct troops on grassy roadside verges – so that it is often possible to include all stages of the cap development and auto-digestion, in a single photograph (Fig. 1.3).

Stinkhorns produce a powerful smelling spore mass, which is dispersed by the clouds of flies attracted to it (Fig. 5.1). The easiest way to locate stinkhorns is in fact by their foetid smell. The first sign of the fruiting body is a white 'egg' breaking the ground. At this stage, if it is cut open lengthwise, beneath the white outer skin can be seen the olive green gelatinous spore mass and a soft white core (Fig. 6.2). When the 'egg' is ripe the cells in the core expand

Plate 17 (Above) Encrusting lichen (*Caloplaca heppiana*) growing on a gravestone. Single grazed flashlight to show the texture. Extension tubes. × 2

Plate 18 Parasitic pick-a-back toadstools (*Asterophora lycoperdoides*) growing on rotting *Russula* sp. Available diffuse lighting with extension tubes. × 1

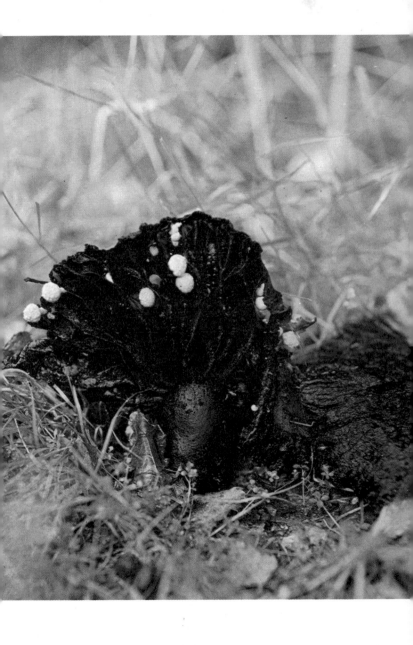

into a hollow sponge-like tube, so that the fungus pushes through the veil and elongates to its full size in a matter of a few hours. On exposure to air, the jelly layer produces the foetid stench which attracts the flies. By feeding on the slime and flying off elsewhere, the flies disperse the spores over a wide area.

Both animals and water are the agents used to disperse spores of the underground truffles. Earthworms and insect larvae crawling through the soil, carry spores on their bodies.

Cup fungi produce their spores on the upper, inner surface of the cup. Unlike cap and bracket fungi, the spores are shot out to a considerable distance so that the spore-bearing surface can, and frequently does, function facing upwards – an impossibility with cap and bracket fungi. A cloud can be produced from a ripe cup in several ways: by sharply tapping it, by breathing on it, by treading close beside it or by bringing it into a different atmosphere. Like the earth star (Fig. 4.1), electronic flash will be essential for recording the cloud-like mist of spores. Even then, quick reactions are needed because the spores disperse so quickly.

Puff-balls and earth stars both have a spectacular means of spore dispersal. The spores are enclosed within a sac. When mature, the sac opens at the top and the spores are dispersed by either the taps of falling raindrops, or small mammals knocking the outside of the sac. They can also be sucked out by wind blowing across the top. The likelihood of ideal conditions occurring in the field for both successful spore dispersal and photography, is remote. The earth star shown in Fig. 4.1 was collected and photographed indoors. Three electronic flashes – two as dual source oblique lighting (page 84) from behind and the third as a fill-in from in front – were used to capture the dispersing cloud of microscopic spores. In some puff-balls, spore dispersal is further aided by the fungus becoming detached and being bowled along by the wind.

The small fruiting bodies of the bird's nest fungi consist of funnel-shaped cups, inside which are small round egg-like structures, each of which contains a mass of spores. Like the puff-balls and earth stars, they rely on rain for their dispersal. Raindrops splash the 'eggs' of spores up out of the cups. Part of the 'egg' then entwines itself around whatever subject it happens to land on – usually a plant, but may be an animal, which will carry it still further. These fungi are not common, so either this elaborate mechanism of spore dispersal is not very successful, or else the fungi are very selective about where they grow. When they are found, they make ideal extreme close-up subjects looking directly down from above.

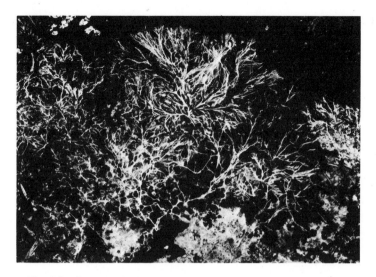

Fig. 4.2 Fungal mycelium growing over the underside of log.
Available diffuse lighting, using extension tubes. ×0·5

A coprophilous fungus called *Pilobolus* which grows on rabbit
droppings (Fig. 6.1), has evolved a spectacular method of spore
dispersal. The tiny stalked heads develop overnight. A black spore
sac is carried on top of a clear swelling resembling an inverted
electric light bulb, which acts as a lens. Light falling on the swelling
is focused on the opposite wall, and this induces the stalk to grow
and bend towards the light. Eventually the swelling bursts, shoot-
ing the spore sac a metre or more away.

Saprophytic fungi

Most of the common fungi which appear amongst grass, or on the
woodland floor, are saprophytes which grow on dead and decay-
ing matter. Saprophytic fungi and bacteria are largely responsible
for the decomposition of plant and animal remains. Such fungi
form the bulk of the photographs in this book, and the techniques
for their photography *in situ*, have already been described. Not all
wood-feeding saprophytic fungi however live on useless fallen
timber; the notorious 'dry rot' fungus causes extensive damage to
constructional timbers which are exposed to high humidity.

Saprophytic moulds grow on foodstuffs (Fig. 4.4) and these are
best photographed indoors under the controlled conditions de-

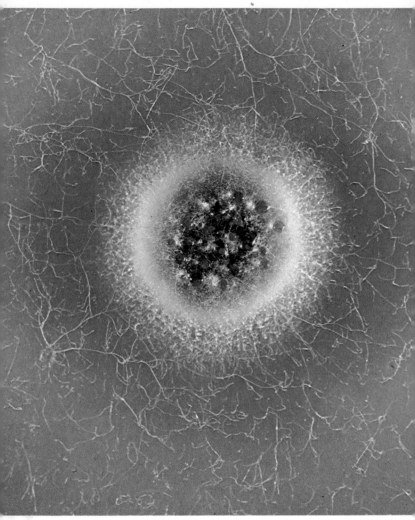

Plate 19 *Penicillium notatum* mould growing over surface of agar. Studio with dual source grazed flashlight to show the branching hyphae. Bellows. ×10 M

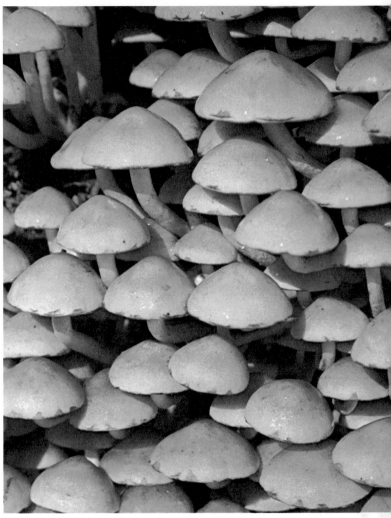

Plate 20 The gregarious sulphur tuft (*Hypholoma fasciculare*)
highlighted by direct sunlight after rain. Extension tubes. ×1

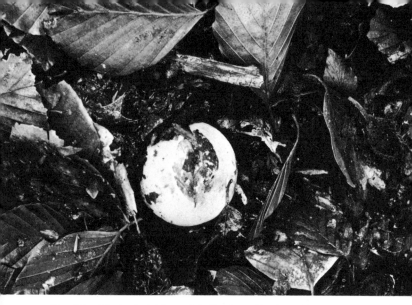

Fig. 4.3 'Egg' of stinkhorn (*Phallus impudicus*) pushing up through leaf-litter in beech woodland. Available diffuse lighting using extension tubes. × 0·5

Fig. 4.4 Saprophytic moulds growing on surface of rice pudding. Available diffuse lighting with extension tubes. × 1

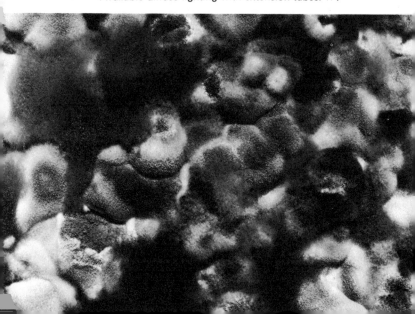

scribed in Chapter 6. Familiar examples of these are the common bread mould *Mucor* and blue-green moulds including *Penicillium*. 'Blue' cheeses are produced by inoculation with a blue-green mould, for example, *Penicillium rocquefortii* (Fig. 4.6) provides the characteristic aroma and flavour of Rocquefort cheese.

Fairy rings are produced not only by *the* fairy ring champignon. Hundreds of fungi grow in circles both in grasslands and in woods (Fig. 2.7), but not all of them produce the rings of distinctly coloured vegetation. The way in which mycelium radiates out from a germinating spore is clearly shown by moulds on agar (Plate 19). Fairy rings will be formed only when the mycelium is perennial and continues to grow outwards as it dies off behind, and also when the fruiting bodies do not generally grow from mycelium produced directly from spores.

Evidence of a fairy ring in a grassland area can be seen throughout the year – even when no fruiting bodies are visible – by a zone of dark green grass encircling an inner bare ring. As the mycelium of the fairy ring champignon continues to grow out, the diameter can increase at a rate of 15–30 centimetres per year. Some of the huge rings on the Downs in Southern England are estimated to be centuries old.

Close examination of a fairy ring reveals four distinct zones. In the central region, the vegetation is normal. Moving outwards, there is a region of actively growing grass; then a zone of dead, brown vegetation and finally a lush zone in which the fruit bodies appear. The actively growing mycelium which produces the fruiting bodies liberates nitrogenous material which stimulates the growth of the turf-forming plants. The dead zone probably results from the mycelium filling the air spaces between the soil particles and thereby reducing the water flow. The inner lush zone is where the turf plants are responding to nutrients released by the dead and decaying mycelium.

Small fairy rings can be photographed from ground level with a standard lens, but larger rings may require a wide angle lens and a high viewpoint such as from the top of a stepladder, a tree or the roof of a building. Extensive fairy rings show up on aerial photographs, and have been mistaken for ancient archaeological sites.

Parasitic fungi

Fungi which feed on living hosts, sometimes continue to live as saprophytes after the host has died. In addition to the larger fungi, such as the honey fungus and brackets which attack trees, many

65

Plate 21 Slug feeding on stinkhorn (*Phallus impudicus*). Available diffuse lighting after a rain shower. ×1

Plate 22 (Far right) Underside of variable slipper toadstool (*Crepidotus variabilis*) showing incomplete gills. Studio with direct flash. Full set of extension tubes. ×6

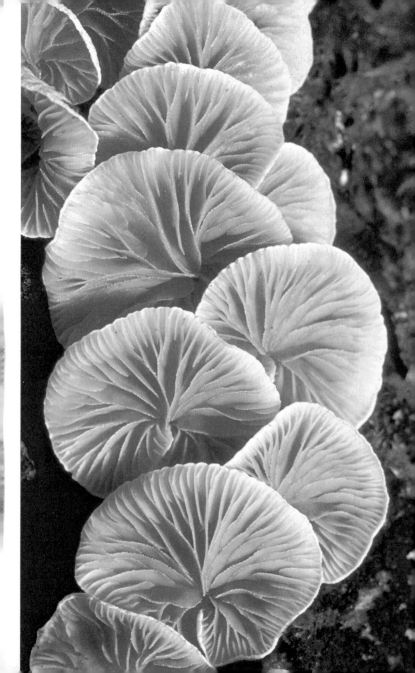

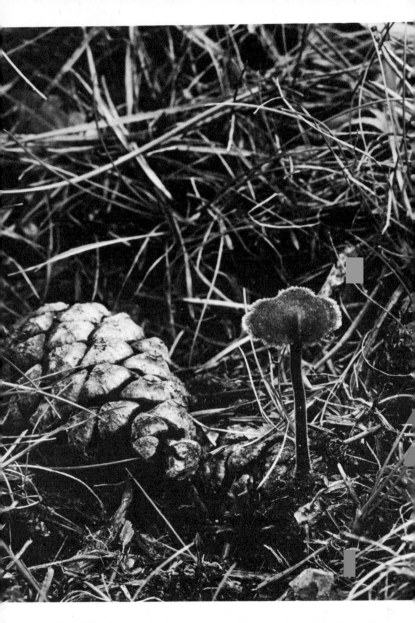

Fig. 4.5 Fir-cone hedgehog fungus (*Auriscalpium vulgare*) growing on a pine cone. Available diffuse lighting, using extension tubes, camera on ground spike. ×1

microscopic fungi cause widespread plant diseases. Amongst these are the rusts and smuts; the blights and wilts of potato and tomato; the mildews and black spot of roses. Many parasitic fungi attack if not a single species, then a group of related species, so that some part of the host should also be included in the photograph.

Fungi themselves are not immune to fungal attack. The parasitic boletus grows attached to the spore tissue of its host – the common earth ball – which it eventually replaces. The bolete usually grows out from its host below ground level, so the region around the fungi should be carefully excavated to show the point of attachment of the two fruiting bodies. The pick-a-back toadstool (Plate 18) which grows in clusters on old decaying specimens of *Russula* and *Lactarius* is a more widespread parasitic species. The black decaying host tissue contrasts well with the mealy caps of the parasite. This fungus is best photographed *in situ*, since the disintegrating host cannot easily be transported intact.

Two examples of fungi which parasitize animals can be seen in Figs. 4.7 and 4.8. The small orange waxy club produced by the caterpillar fungus is proof that below ground lies the remains of a lepidopterous caterpillar or pupa. Spores of the fungus will germinate only if they land on moist caterpillar skin. The mycelium penetrates the host and eventually replaces its insides. The rough surface of the fruiting body can be seen with a hand lens, or viewed through a full set of extension tubes (Fig. 4.7).

Very rarely will any evidence of the host be visible above ground, and so, as with the parasitic boletus, excavations will have to be made before the whole story can be shown in a photograph. Unless great care is taken in removing the grass, roots and soil (by means of scissors, forceps or a small spatula), the fungus can very easily become torn away from its host.

The caterpillar fungus in Fig. 4.7 was collected for photography indoors so that the lighting could be controlled, and the maximum depth of field gained, without any distracting objects appearing in the field of view. This picture can be regarded solely as a scientific record of a parasite and its host. It makes no attempt to illustrate the habitat where it was found, because so far as the fungus is concerned, the habitat is irrelevant since its survival depends on the chance landing of a spore on to a caterpillar. A useful pair of pictures is provided by photographs taken at the same magnification, of the fungus as found *in situ*, and also after excavation down to the level of the caterpillar.

Anglers and aquarists will be familiar with the cotton wool disease or 'fluff' which can develop on both free living and captive

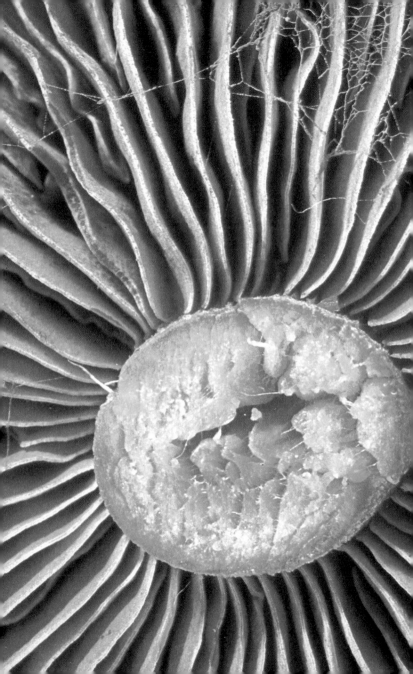

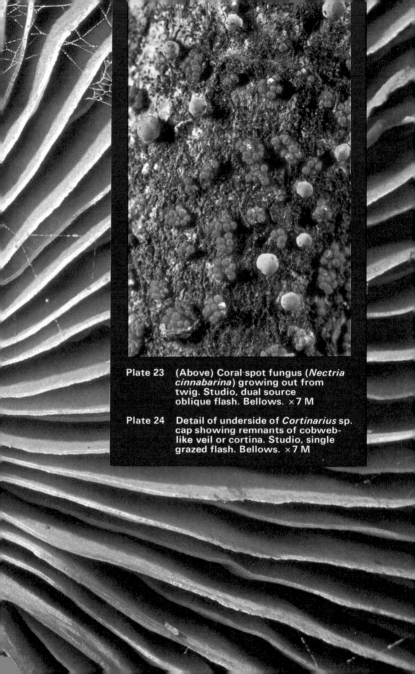

Plate 23 (Above) Coral-spot fungus (*Nectria cinnabarina*) growing out from twig. Studio, dual source oblique flash. Bellows. ×7 M

Plate 24 Detail of underside of *Cortinarius* sp. cap showing remnants of cobweb-like veil or cortina. Studio, single grazed flash. Bellows. ×7 M

Fig. 4.6 Detail of Rocquefort cheese showing characteristic darkening
 caused by blue-green mould (*Penicillium rocquefortii*).
 Studio using extension tubes and diffuse daylight shining
 through window. ×2

Fig. 4.7 Parasitic caterpillar fungus (*Cordyceps militaris*) excavated
 from ground to show intimate association with caterpillar.
 Studio with direct flash and fill-in reflector. Full set of
 extension tubes. ×1·5

fish (Fig. 4.8). This disease is caused by a Phycomycete called *Saprolegnia*. Fish which are damaged during capture and transference to an aquarium, are most prone to attack by the water-borne spores. Unless the disease is treated in the early stages it will soon kill fish, including salmon and trout in the wild. Photographs of dead fish removed from the water and laid out on the ground, will show the lesions, but will not convey the typical fluffy appearance of the fungus when seen underwater. This feature can be shown only by photographing the fish in an aquarium. As aquarium photography is not applicable to fungi in general, only the major pitfalls are outlined below. A much fuller account of the techniques is given in the Chapter on Aquatic Insects in the companion volume on INSECTS.

Firstly, the aquarium should be clean and scratch-free. For this reason, glass sides are preferable to Perspex ones, which so easily become scratched. Reflections of the camera, as well as the photographer's hands, will appear in the front face of the aquarium, unless a matt black mask is mounted on to the front of the camera. Cut out a central hole large enough to ensure the field of view is not restricted at the maximum aperture of the lens.

Lighting can be by means of photofloods or by flashlight. When using photofloods or any other continuous artificial light source, a yellow cast will appear on daylight colour film. Therefore, either artificial light filmstock or a daylight colour film with a colour conversion filter such as a Wratten 80B should be used. The main disadvantage of using such a filter is that there is considerable loss in the film speed. For instance, Kodachrome II (25 ASA) becomes re-rated to 8 ASA. Electronic flash will be preferable for arresting movement of the fish – although a diseased fish is more likely to remain static for longer than a healthy individual. A single flash can be directed down through the top of the tank, or through one side with a fill-in reflector on the other. Lighting through the front of the aquarium is not recommended, since unless the light source is positioned well to one side of the camera – at an angle of less than 45° to the front glass – its reflection will appear in the glass.

Human diseases caused by fungi include ringworm, athlete's foot and aspergillosis – an infection of the lungs caused by a common mould.

Symbiotic fungi
Unlike parasitism, which is a unilateral association between two different species, symbiosis is a mutually beneficial relationship in which both species gain some benefit from the other's presence.

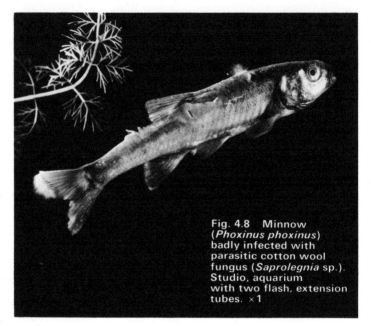

Fig. 4.8 Minnow (*Phoxinus phoxinus*) badly infected with parasitic cotton wool fungus (*Saprolegnia* sp.). Studio, aquarium with two flash, extension tubes. ×1

Many fungi are symbiotic, brief mention has already been made of the mycorrhizal association, and lichens are another example of a symbiotic fungal association.

Mutually beneficial relationships also exist between fungi and insects. The spores of a *Stereum* fungus are stored by the female wood wasp or horntail, in special glands. She uses her ovipositor to bore into wood, where she lays her eggs, and at the same time, deposits some of the fungal spores. After germination, the spores digest the wood so that it becomes more suitable for the young wasp larvae.

Mycorrhiza or 'fungus root' is an association which develops between the fungal mycelium and roots of trees or other flowering plants – including orchids. The distribution of mycorrhizal fungi is therefore limited to where their partners are already growing. An ectotrophic mycorrhiza is an external association in which the fungus forms a whitish growth around the smaller roots; while an endotrophic mycorrhiza penetrates inside the roots. These associations permit an exchange of nutrients between both partners.

By noting where mycorrhizal fungi appear, photography of their underground mycorrhiza can be done during any month of the year. The white branching mycelium of fungi in general can also be found throughout the year, beneath fallen logs (Fig. 4.2).

Lichens are dual organisms formed from the symbiotic association of two lower plants – a fungus with an alga. The fungal partner is usually an Ascomycete, but sometimes a Basidiomycete. It gives the lichen its shape and form, and provides shelter and moisture for the alga. In turn, the alga, being a green plant, is able to utilize energy from the sun to manufacture sugars and other organic food.

With the exception of polluted areas, lichens grow in most habitats. They can be found on walls, on roofs and on gravestones in churchyards (Plate 17), on trunks and twigs, bare soil and mountain rocks. Flat encrusting *crustose* lichens grow in close association with the substrate. Leaf-like *foliose* lichens are attached only by root-like threads; while *fruticose* lichens are either upright or hanging branched forms.

Close-up photography is essential for lichens. The intricate detail of branched and foliose lichens will be shown only by using the maximum depth of field. For this reason, flashlight will be useful for photographing such forms which can move on a windy day. Encrusting lichens, growing over a flat surface, such as a gravestone or a wall, are easy to photograph since the depth of field required will be minimal. These are therefore good subjects to take on dull or windy days – even without flashlight.

Extreme low-angled side lighting – known as grazed or textured lighting – is ideal for showing the surface texture of encrusting lichens (Plate 17). A single light source is held on a level with the subject so that any slight irregularities on the lichen surface, are emphasized by their shadows cast from the direct lighting.

Lichens growing on small rocks or twigs, can be collected for photography inside. Beard lichens are good subjects for back-lighting with a pair of flashes or spotlights. Care must be taken to ensure the lights are not aimed directly at the lens, otherwise flare will result. Continuous light sources, such as spotlights, will be easier for checking the final effect.

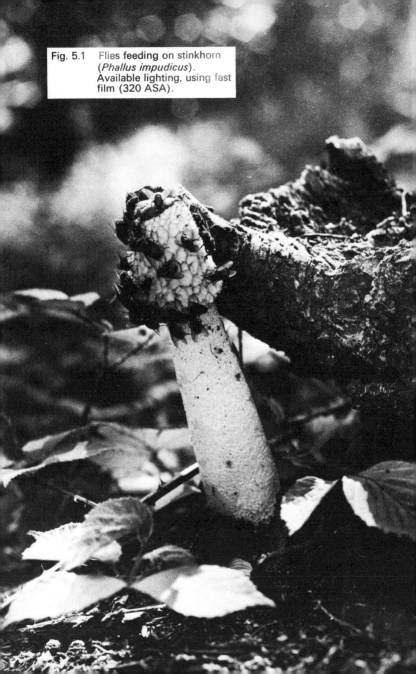

Fig. 5.1 Flies feeding on stinkhorn (*Phallus impudicus*). Available lighting, using fast film (320 ASA).

CHAPTER 5 EDIBLE AND POISONOUS FUNGI

Two additional approaches to collecting photographs of unrelated fungi are to search for the edible species as distinct from the poisonous species. Since there is no clear-cut way of distinguishing a poisonous from an edible fungus, correct identification is vital if, after the photography the 'edible' specimens are collected for eating.

Many fungi are edible, but only a few are really palatable; the rest are either tasteless, tough or unpleasant to eat. Fortunately, the proportion of deadly poisonous fungi is much lower than poisonous flowering plants. But many toadstools are 'suspect' – in that the side effects they produce will vary from one individual to another. A fungus which has been eaten by insect larvae, beetles, slugs or squirrels, is no proof that it is safe for human consumption. Slug damage is, after all, often present on the deadly poisonous death cap. The fungal poisons are broken down into harmless components by antibodies produced by the predators. Old superstitions are equally unreliable. A fungus which can be peeled, which is growing in grass, or which does not blacken a silver spoon, cannot be infallibly trusted to be an edible species. Neither do all poisonous fungi smell unpleasant.

Man and fungi

Today, in Britain, the cultivated mushroom – related to the common mushroom – is the only species cultivated on a large scale (Fig. 5.2). During the last century, Covent Garden market sold half a dozen kinds of fungi and in the Midlands, blewits were also sold in markets. Except for mycogastronomiques, who eagerly seek out chanterelles, parasols, shaggy ink caps, horn of plenty, morels and some boletes, species other than the mushroom are rarely eaten now in Britain. The edible boletus (the *cèpe* of France and the *Steinpilz* of Germany) is the mushroom which is used in dried and canned so-called 'mushroom' soup. In Europe, many kinds of edible fungi are collected and eaten – nearly 300 different kinds are allowed to be sold in Swedish markets. In the Far East, fungi – including the jew's ear fungus – are cultivated on logs and branches.

As well as photographs of edible fungi growing *in situ*, pictures can be taken of the way in which fungi such as truffles are collected using animals. Pictures of indoor commercial mushroom farms

will have to be taken with artificial lights. For a general view showing the massed effect of mushrooms in trays or shelves (Fig. 5.2), several continuous light sources will provide a larger area of illumination than a single narrow-beamed flashlight. A wide angle lens may also be preferable to a standard lens.

The blackish ergots produced on rye and other grasses, are deadly poisonous. Ergotine poisoning, due to eating rye bread made from infected grain, was common in the Middle Ages. But like many poisonous plants, a useful drug is extracted from ergot. It is used to speed up the contraction of uterine muscles during labour and to stop excessive bleeding and haemorrhages by constricting blood vessels. Ergots can be photographed outside on their host plant, in late summer; but since long-stalked plants are rarely stationary, it will be easier to collect an infected ear for close-up photography indoors.

Another fungus beneficial to man, is the blue-green mould, *Penicillium notatum*, from which the antibiotic penicillin is obtained. Plate 19 showing the mould growing over the agar was taken indoors. The camera was supported on a copying stand above the petri dish. A bench light was used to view the effects of lighting the mould from different angles and the photograph taken by using two electronic flashes on a level with the dish so as to define the hyphal threads penetrating into the agar. The cover of the plastic petri dish was removed for photography which meant that the agar became contaminated with spores of other moulds and so this culture could not be used for taking a series of the way *Penicillium* increases its circumference. There are two alternative solutions to this problem; either use a clean and optically clear glass cover when inoculating the culture, or else photograph several cultures at progressively later stages of their development.

Fungal visitors

Animals use fungi as food sources as well as breeding sites. Evidence of attacks by slugs and squirrels on fungi, are commonplace, but the opportunities for photographing these visitors are few and far between. Rain showers, however, bring out slugs and snails. Plate 21 was taken by available light on a drizzly mid-summer day – not normally inducive to photography – but ideal weather for finding slugs and for photographing spiders' webs.

A freshly emergent stinkhorn will soon attract blue-bottle and carrion flies to feed on its evil-smelling spore mass. I have also seen

78

Fig. 5.2 Cultivated mushrooms (*Agaricus hortensis*) growing on a shelf in a mushroom farm. Single photoflood.

Fig. 5.3 Fungus beetle (*Tetratoma fungorum*) feeding at night on underside of razor strop fungus (*Piptoporus betulinus*). Studio, using bounced flash. Full set of extension tubes. ×10

a wasp making repeated visits to a stinkhorn, temporarily driving off the flies. The movements of the visitors can be arrested with electronic flash, but unless it is bounced, it will tend to burn out all detail of the white spongy stipe. A better technique is to use a fast film so that a fast shutter speed can be used with a relatively small aperture. Figure 5.1 was taken on TRI-X (320 ASA) at $1/250$ second. The out-of-focus woodland setting is not so stark as the dark background typically produced by using direct flashlight. Additional speed can be gained with colour film by double rating it (page 24).

Insect communities develop inside both brackets and agarics. These communities consist of non-breeding visitors as well as resident breeders. The latter, which are small in size, are mainly beetles and flies. Beetles tend to parasitize brackets, while flies favour the softer agarics. There is a distinct succession of fungal visitors. The first colonizers feed on the living fungus tissue, either on the hyphae or on the spores. These are superceded by insects which feed on the dead hard brackets, and finally these are taken over by a set which feeds on soft decaying brackets and agarics.

The present evidence seems to indicate that an insect does not confine itself to a single host species, although some are frequently found on a particular species. For example, *Tetratoma fungorum* most often occurs in the razor strop fungus or birch polypore. The beetle lays its eggs in small bark crevices of the birch tree. When the larvae hatch, they burrow into the fungus where they feed. The fully grown larvae drop to the ground and pupate in the soil. The adult beetles shelter during the day in bark crevices. At night they move onto the brackets to feed on the undersides (Fig. 5.3). So that the birch tree, the birch polypore and the soil, are all utilized by the beetle during some stage of its life history.

Figure 5.3 was taken in the studio. A living birch polypore was collected in late autumn and placed in a vivarium. Late in the evening, several beetles crawled out from the bark crevices above the bracket. Bounced electronic flash was used to photograph them feeding and crawling over the underside of the fungus.

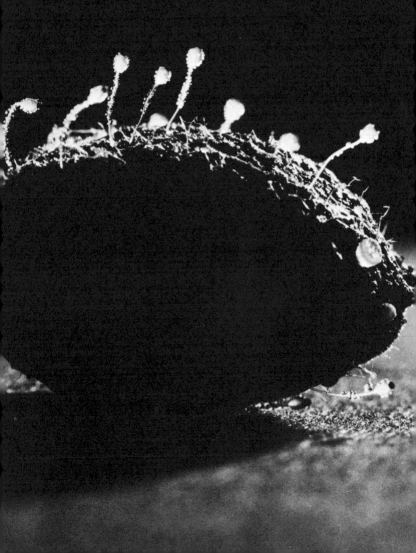

Fig. 6.1 Coprophilous fungi
(*Pilobolus* sp.) growing
on rabbit dung. Studio
with single oblique flash
from behind. Bellows.
×11 M

Small fungal fruiting bodies and moulds, as well as portions of larger fruiting bodies will be easier to photograph if they are brought indoors. The methods of collection and keeping fungi have already been described on page 12.

Photography

All specimens should be photographed as soon as possible after collection, before they begin to shrivel up. The photography can be done on a table top or a work bench.

Props Support the camera either on a tripod standing on the floor or on a small table-top tripod directly on the work top. A copying stand or a copipod is a useful camera support for photographing the underside of flat brackets or sections of fungi.

If small fungi are collected attached to wood or leaves, the substrate will provide a natural background. Extreme close-ups of part of a large fungus can completely fill the frame; so that artificial backgrounds will be needed only for photographing fungi which have been either uprooted (Fig. 4.7) or sectioned (Fig. 6.2). A layer of soil or ground litter collected from alongside the specimen, spread over a plastic seed tray will make a naturalistic background for larger species such as a sectioned stinkhorn (Fig. 6.2). Alternatively, plain coloured backgrounds are ideal for anatomical pictures. Black velvet is an effective and dramatic background for indoor photography in both colour and monochrome, but for some subjects, grey may be a better alternative. Pale-coloured artists' boards provide variety to colour pictures, but avoid brightly coloured backgrounds, since they may throw an unnatural cast over the fungus. The specimen can either be laid directly on to the bottom of a curved piece of card or on to a sheet of glass raised up from the background. Stalked fungi can be held in position by wedging them into a flower-arranger's pin-holder.

Lighting If the photography is done during the daytime, natural lighting can be used as the sole light source indoors. This will be like photographing in the field, with the additional advantage of no wind. It is much more likely however, that the daylight hours will be spent collecting and so the photography will be left until the evening when some sort of artificial light source – either photofloods or flash – will have to be used. Photofloods emit a good deal

of heat and so unless a suitable heat filter is used, they will accelerate the drying of the specimen. An ordinary 60-watt household bulb produces considerably less heat. For both these light sources use either artificial light colour film or a colour conversion filter such as 80B, with daylight colour film.

Whatever kind of lighting is used, try to avoid a stereotyped set-up. Select the direction of the light source(s) specifically for each subject. Look for the best effect of light and shade falling on the subject by using a continuous light source, such as an Angle-poise lamp, and viewing through an SLR camera. When the best positions for the lights have been found, substitute them with the flash. Some professional flash units have their own built-in modelling lights for viewing the lighting effects.

Frontal lighting from a single light source close beside the camera, in front of the subject, lacks any modelling, and will cast a shadow of the subject on to a pale background. Better modelling will be gained if the light is moved to one side of the subject (oblique lighting). The unlit side of the subject can be filled in by bouncing the light off either a white board or a reflector. Grazed lighting (page 75) is ideal for showing surface texture (Fig. 7.3), and also for emphasizing the inter-gill spaces (Plate 24) and the pores on the underside of cap and bracket fungi (Fig. 7.2). The fine 'cobwebs' seen overlying the gills in Plate 24, are a characteristic feature of the genus *Cortinarius*. In young specimens, this veil or *cortina* stretches across the edge of the cap to the stipe. Two light sources permit dual source oblique lighting – from in front or behind the subject. Back lighting is particularly effective for translucent fungi and for highlighting a spore cloud (Fig. 4.1). A tube of matt black paper wrapped around the edge of the light, or the flash, will produce a more directional beam, and reduce the chance of flare.

A ring flash is a quick method of getting a record picture without any distracting background shadows; but it produces very 'flat' lighting. With a bit of thought and time, more exciting ways of lighting a close-up subject will be found.

At magnifications of greater than 1:1, definition will be improved by reversing the lens. This is done by attaching a reversing ring to the filter mount on the front of the lens so that it can be connected to the free end of the bellows. The automatic lens coupling of a FAD lens no longer functions after reversal.

For all close-ups, particularly for macrophotographs, it is important to record the magnification of the subject as it appears on the negative or the transparency. Some bellows have the magnifi-

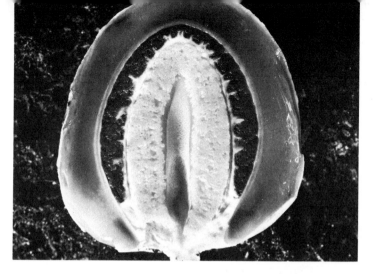

Fig. 6.2 Section through stinkhorn 'egg' (*Phallus impudicus*)
showing spongy internal core surrounded by darker spore
mass. Studio, using grazed flashlight. Extension tubes. × 1·5

cation scale for use with a standard lens, engraved on the focusing
rack. For bellows which have no focusing rack, as well as extension
tubes, a focusing slide mounted between the tripod and the camera,
will enable critical focusing at close range without altering the
magnification. The magnification will be changed by using either
a longer or a shorter focal length lens. The perspective will also
vary with the focal length of the lens used. Thus a compromise
between various conflicting factors will govern the choice of which
lens to use: an acceptable perspective, the minimum amount of
extension (for maintaining a rigid set-up) and the minimum
camera-to-subject distance permitting adequate subject lighting.

For a given amount of extension, a greater magnification will be
gained with a wide angle lens, but with a corresponding reduction
in the lens-to-subject distance. Similarly, a long focus lens will
produce a smaller magnification, and an increased lens-to-subject
distance.

Sections Photographs of cut sections of fungi can provide useful
information about a species which will not be visible in a straight
ecological picture. Sections show the difference between the
colour of the internal flesh and the outer cap, as well as the colour
change which occurs in some species when the flesh is damaged.

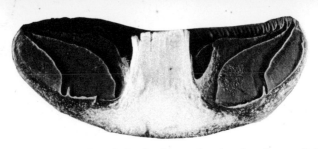

Fig. 6.3 Section through *Cortinarius* sp. showing short intermediate gills. Studio using single flash held below glass plate. Extension tubes × 2

This colour change is due to the oxidation of substances in the cell sap. Most boletes temporarily turn blue, the flesh soon reverting to its original colour. In contrast, damaged flesh of the blusher turns permanently pink; so that when a blusher is photographed in colour in the field, any portion which has been eaten by animals, will clearly show in the picture.

A section through the 'egg' stage of an *Amanita* shows the universal veil enclosing the young toadstool. The gills are also covered by a thin membrane – the partial veil. As the toadstool expands, both veils rupture and, characteristically of the amanitas, their remnants are visible in the mature fungus. The universal veil becomes the basal sac or volva (Plate 5), while the partial veil can be seen as a ring of tissue – the annulus – near the top of the stipe. On some amanitas, notably the fly agaric (Plate 2 and Fig. 7.4), remnants of the universal veil remain on top of the cap as white specks.

The colour of the developing spore mass inside puff-balls, earth balls and earth stars will also show in a section. Lighting the matt surface of a sectioned earth ball creates few problems, but since the wet cut surface of a stinkhorn 'egg' is highly reflective, it is essential to critically view the subject through an SLR camera to check for distracting reflections. A single light source will produce fewer highlights than two or more light sources, and extreme angled lighting (Fig. 6.2) will be better than overhead lighting.

Figure 6.3 of a sectioned *Cortinarius* was taken by laying the specimen on a sheet of plate glass raised up from the background. A single flash was directed up on to the fungus by holding it below the level of the glass and the camera lens, so that the outline of the incomplete gills was accentuated by their outline shadow.

Spore prints Both the colour and the shape of spores can be crucial for identification of a fungus. Spore prints are made from mature,

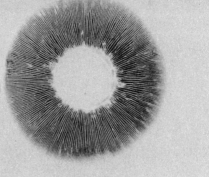

Fig. 6.4 Spore print of cultivated mushroom (*Agaricus hortensis*). Studio using extension tubes and diffuse daylight shining through window. ×1

but not decomposing, specimens. Cut off the stipe of an agaric and lay it on a piece of paper with the gills or pores facing downwards. Likewise, lay a bracket with the pore surface touching the paper. Leave the specimen for several hours or overnight covered with a jam jar or bowl, both to prevent it from shrivelling and to keep draughts from spoiling the pattern produced by the fine rain of spores. Small specimens can be placed in plastic boxes or tins with a piece of damp cotton wool.

As the spores are shed, they will fall onto the paper forming a print, which will show both the spore colour and the gill or pore pattern (Fig. 6.4). Some of the spores can be transferred on to a glass slide for later microscopic examination. If a spore print is to be photographed, it should contrast well with the colour or tone of the paper. Thus, fungi which produce coloured spores are best laid on white or pastel-coloured paper, while black paper will be preferable for white-spored fungi. If the spore colour is not immediately apparent, take a quick spore print to determine the colour and then select the appropriately coloured paper for the final spore print. Alternatively, the spore print can be made on a sheet of glass and the background colour selected afterwards. Use only perfect specimens for making spore prints, as any damage to the underside of the fruiting body, will be apparent in the print. Care must be taken not to damage the print as the fungus is removed from the paper. A pin or a piece of wood stuck beforehand into the top of the fungus, will make a useful handle. The spore print can be made permanent by spraying it with a clear matt spray available from art supply shops.

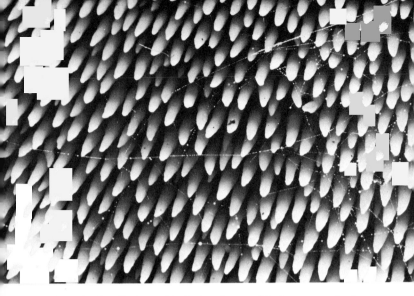

Fig. 7.1 Detail of wood hedgehog fungus (*Hydnum repandum*) showing spines on underside. Studio, with grazed flash. Bellows. ×5 M

Fig. 7.2 Detail of pores on underside of bay bolete (*Boletus badius*). Studio, with grazed flash. Bellows. ×7·5 M

The circle is the most widespread design amongst fungi. The majority of cap fungi show a radial symmetry, which is lost in forms with the stipe offset from the centre. When viewed from above, most cap fungi have a plain uni-toned cap, which provides little scope for pattern pictures. However, the parasol mushroom, the old man of the woods, many *Pholiota* species and a tooth fungus called *Sarcodon imbricatum*, all have radiating patterns of brown scales on the top of their caps. Close-up photographs of these scales can provide a welcome pictorial relief in a series of portrait studies of complete fungi.

One of the best examples of radial symmetry in the plant kingdom is the underside of a gilled fungus with a centrally placed stipe. If fungi are growing out at an angle, then it is possible to photograph them *in situ* to show the gills and the stipe. But for detailed close-ups, photograph them indoors using a bellows extension. Remove the stipe so that no shadow is cast over the gills. Lay the fungus cap side downmost and photograph it with the camera supported overhead on a copipod or on a reversed head of a tripod, as described on page 17. Since the colour and pattern of the gills and the inter-gill spaces are repeated right around the circumference of a gill fungus, a photograph need not include the entire gill area. A portion will provide just as much information, as well as a more striking picture. If a completely circular object is photographed in the middle of the rectangular 35mm frame, inevitably there is a considerable area of redundant background which appears at either end of the frame; whereas a square format is more suitable for illustrating this kind of symmetry. Other examples of radial symmetry in fungi are earth stars (Plate 7) and puff-balls (Fig. 2.6). The hard brown fruiting bodies produced by *Daldinia concentrica*, aptly known as King Alfred's cakes, have distinct concentric markings inside them.

Bolete pores are examples of polygonal forms of symmetry. At magnifications of several times greater than life size (Fig. 7.2), these make dramatic photographs in both monochrome and colour. Repetitive designs are less common amongst fungi, a notable one is the remains of the universal veil on the cap of some *Amanita* species. The most striking contrast is provided by the red-capped fly agaric (Plate 2). Figure 7.4 shows a close-up of part of an immature cap taken in the field in Scotland, with a portion of the cap completely filling the frame so that no part of the background

appeared in the picture. The detail of the teeth on the underside of the hedgehog fungus (Fig. 7.1) and the surface features of the common earth ball (Fig. 7.3) are both repetitive fungal designs. Still more will be found if they are sought out; for example the patterning of the magpie ink cap and the mica particles on the freshly formed caps of glistening ink caps (Plate 14).

The motivation behind finding and taking such pattern pictures is pictorial and therefore quite distinct from record photographs showing fungal anatomy and ecology.

Fig. 7.3 Detail of common earth ball (*Scleroderma citrinum*) showing polygonal pattern on upper surface. Studio with grazed flash. Extension tubes. × 3

Fig. 7.4 Detail of fly agaric (*Amanita muscaria*) cap showing remnants of universal veil. Available lighting in the field. × 1

APPENDICES
A PHOTOGRAPHIC GLOSSARY

Aperture Iris diaphragm of lens which controls amount of light reaching film. Calibrated in 'numerical apertures' (f numbers or stops) which change by a factor of 1.4 ($\sqrt{2}$) in one stop increments in series 1, 1.4, 2, 2.8, 4, 16, 22

Artificial light film Colour filmstock for use with photoflood bulbs.

Ball-and-socket head Attached to tripod or other support to allow tilt and rotation of camera or flash.

Bellows Variable extension inserted between the lens and the camera body for close-up photography, allowing magnifications of greater than life size (1:1).

Bounced lighting Indirect diffuse lighting obtained by deflecting the light off a white board, wall or umbrella, above or to one side of the subject.

Close-up lens Attached to camera lens for close-up photography.

Colour cast Unnatural colouring due to using the incorrect film with a particular lighting (e.g. daylight film with photofloods), to reflection from a coloured surface or to reciprocity failure.

Conversion filter Used with colour films to correct overall colour balance, e.g. blue Wratten 80B used with daylight colour films and photoflood lighting; and orange Wratten 85 used with artificial light colour films in daylight.

Copipod Camera support with four legs used for overhead photography, especially copying work.

Depth of field Zone of sharp focus behind and in front of plane of focus. Increased by using a smaller aperture or by decreasing the image size.

Diaphragm See Fully automatic diaphragm and Preset diaphragm.

Diaphragm shutter Iris type shutter which allows synchronization with electronic flash at all speeds.

Diffuse lighting Soft lighting which produces soft edged shadows, and least obvious highlights on shiny objects.

Electronic flash Reusable flash which produces an instantaneous discharge in a gas-filled tube.

Exposure Correct combination of shutter speed and lens aperture used to produce a good negative or transparency for a given film at a particular light intensity.

Extension tubes Inserted between the camera body and the lens for close-up photography. Automatic tubes retain the fully automatic diaphragm mechanism.

Film speed Relative sensitivity of a film to light, expressed either as an ASA or a DIN rating. 'Slow' films have a low rating and require more light than 'fast' films.

Filter Alters the nature of light passing through the lens to the film, by absorbing particular wavelengths.

Flare Bright spots or patches formed by strong light reflections inside the lens, when the camera is pointed towards a light source. Flare can be reduced by using a lens hood or a multi-coated lens.

Focal plane shutter Camera shutter positioned immediately in front of the film plane, made of fabric or metal blinds.

Focus Adjusting the lens-film distance so that the subject image appears sharp on the film plane.

Focusing slide Used mounted on a tripod, it allows the camera to be moved towards or away from the subject for critical focusing in close-up work, without altering the magnification.

Frame A single exposure amongst a series on a film.

Fully automatic diaphragm (FAD) Allows lens to remain at full aperture until shutter release is operated, when the diaphragm closes down to the pre-selected aperture.

91

Grazed lighting (Textured lighting) Extreme low angled oblique lighting used for emphasizing texture.

Ground spike Camera support for ground level subjects, the base of which is pushed into the ground.

Guide number (Flash factor) When divided by the subject distance, indicates correct aperture (or vice versa). Does *not* apply for close-ups.

Incident light reading Measures the light falling on the subject. The light meter, with a diffuser attached, is pointed in the subject to camera direction.

Lens hood Projects in front of lens. It reduces the possibility of back lighting striking the front surface of the lens and thereby causing flare.

Long focus lens Has a focal length greater than the standard lens, and increases the camera to subject distance for a given image size.

Macro lens A lens with built-in extension allowing magnifications of up to 0·5 without using extension tubes or bellows.

Monopod A single legged camera support.

Non-reflex camera Includes field and viewfinder cameras which do not view the subject directly through the lens.

Over-exposure Due to excessive light reaching the film, colour transparencies appear thin and negatives dense.

Parallax The discrepancy between the image seen through the viewfinder, or the upper lens of a TLR camera, and the image recorded on the film.

Pentaprism Five-sided prism used in SLR cameras to ensure the image is correctly orientated in the viewfinder.

Photoflood Artificial light used for studio work for monochrome and artificial light colour films.

Preset diaphragm (PD) A non-automatic diaphragm in which the iris must be stopped down manually to the preset aperture.

Reciprocity failure According to the Reciprocity Law, exposure equals light intensity × time. With short ($<^1/_{1000}$ second) and long ($>^1/_2$ second for colour films) exposures the Law fails, film speed is lost and the colour balance shifts.

Reflected light reading Measures the light reflected from the subject. The light meter is directed away from the camera towards the subject.

Reflex camera Has ground glass screen for critical composition and focusing. Twin lens reflex (TLR) cameras have two lenses, one for viewing and one for taking, while single lens reflex (SLR) cameras have one lens only.

Reversing ring Accessory for mounting the lens on the camera body in the reverse position for macrophotography.

Ring flash Electronic flash which encircles the camera lens. Provides frontal lighting in extreme close-ups.

SLR *See* Reflex camera.

Standard lens Has a focal length approximately equal to the diagonal of the negative or transparency, giving an angle of view of 45–50°.

Stop (f number) Numerical aperture of lens iris diaphragm which controls the intensity of light reaching the film.

Synchro-sunlight Balanced combination of sunlight and flashlight.

TLR *See* Reflex camera.

TTL (Through the lens) meter Reflected light meter built into a SLR camera which measures the light passing through the lens.

Transmitted light Light which passes through the subject.

Under-exposure Due to insufficient light reaching the film, colour transparencies appear dense and negatives thin.

Wide angle lens Short focal length lens giving a wider angle of view (greater than 50°) than a standard lens used from the same position.

B EQUIPMENT CHECK LIST FOR
PHOTOGRAPHING FUNGI

Basic field equipment

Camera with standard lens { (50mm for 35mm format) } with lens hood
{ (80mm for 6 × 6cm format) }

Light meter (if camera does not have TTL metering)

Films	Torch for focusing in dark wood
Tripod	Scissors and knife
Ground spike	Mirror
Spare batteries for TTL meter	Reflector
Cable release	Umbrella
Lens tissues and lens brush	Binoculars
Close-up lenses and/or extension tubes	Fern trowel or 'widger'
Gadget bag or foam-padded rucksack	Trug, tins and boxes
Plastic sheet for kneeling on	Notebook or pocket tape recorder

Additional field equipment

Medium long focus lens { (105 or 135mm for 35mm format) } with lens hood
{ (150 or 250mm for 6 × 6cm format) }

Macro lens	Right-angled flash bracket
Bellows	A monopod or spike with flash shoe
Focusing slide	Waist level or right angle viewfinder
Flash (bulb or electronic)	Stepladder

Additional studio equipment

Table-top tripod	Sheets of glass
Copying stand	Plasticine
Black velvet	Ring flash
Board backgrounds	Reversing ring
Spotlights	Plastic seed trays
Photofloods	Flower-arranger's pinholder
White card	Aquarium

C THE NATURE PHOTOGRAPHERS'
CODE OF PRACTICE

All photographers working in Britain should read the leaflet: *The Nature Photographers' Code of Practice*, produced by the Association of Natural History Photographic Societies. Copies can be obtained from the RSPB, The Lodge, Sandy, Bedfordshire, SG19 2DL, by sending a stamped addressed envelope.

D BOOKS FOR FURTHER READING AND IDENTIFICATION

A comprehensive list of titles can be found in the *Guide to the Literature for the Identification of British Fungi*, published by the Foray Committee of the British Mycological Society, 2nd edn. 1968.

* Extensively illustrated with photographs.
† For identification of fungi.

* Angel, Heather, *Nature Photography: Its art and techniques*, Fountain Press/ M.A.P., Kings Langley, 1972.

† Brightman, F. H. and Nicholson, B. E., *The Oxford Book of Flowerless Plants*, Oxford University Press, 1966.

† Dennis, R. W. G., *British Ascomycetes*, J. Cramer, Lehre, 1968.

† *Edible and Poisonous Fungi*, Bulletin No. 23 of the Ministry of Agriculture and Fisheries, HMSO, London, 1945.

† Findlay, W. P. K., *Wayside and Woodland Fungi*, Warne, London, 1967.

† Haas, H., *The Young Specialist Looks at Fungi*, Burke, London, 1969.

† Henderson, D. M., Orton, P. D. and Watling, R., *British Fungus Flora. Agarics and Boleti: Introduction*, HMSO, Edinburgh, 1969.

† Hvass, E. and H., *Mushrooms and Toadstools in Colour*, Blandford, London, 1961.

† Kauffman, C. H., *The gilled mushrooms (Agaricaceae) of Michigan and the Great Lakes Region*, 2 vols. Dover, N.Y., 1971.

* Kleijn, H., *Mushrooms and other fungi*, Oldbourne, London, 1962.

† Kreiger, L. C. C., *The mushroom handbook*, Dover, N.Y., 1967.

† Kühner, R. and Romagnesi, H., *Flore analytique des champignons supérieurs*, Masson et Cie, Paris, 1953.

† Lange, M. and Hora, F. B., *Guide to Mushrooms and Toadstools*, Collins, London, 1963.

† Martin, G. W. and Alexopoulus, C. J., *The Myxomycetes*, University of Iowa Press, 1969.

† Maublanc, A., *Les Champignons de France*, 2 vols., Paul Lechevalier, Paris, 1946.

† Michael, E. and Hennig, B., *Handbuch für Pilzfreunde* (5 vols.), G. Fischer, Jena, 1958-1970.

† Moser, M., *Kleine Krytogamenflora von Mitteleuropa* (ed. H. Gams), Band IIb, Basidiomyceten II Die Röhrlinge und Blätterpilze (Agaricales), 3rd ed. Gustav Fischer Verlag, Stuttgart, 1967.

Pilát, A. and Ušák, O., *A Handbook of Mushrooms*, Spring Books, London, 1954.

† Pilát, A. and Ušák, O., *Mushrooms and Other Fungi*, Peter Nevill, London, 1961.

† Pilát, A. and Ušák, O., *Mushrooms*, H. W. Bijl, Amsterdam, 1958.

* Ramsbottom, J., *Mushrooms and Toadstools*, Collins, London, 1953.

† Ramsbottom, J., *A Handbook of the Larger British Fungi*, British Museum (Nat. Hist.), London, 1965.

* Savonius, M., *All Colour Book of Mushrooms and Fungi*, Octopus, London, 1973.

† Smith, A. H., *The Mushroom hunter's field guide*, University of Michigan Press, Ann Arbor, 1963.

† Smith, H. V. and Smith, A. H., *How to know the non-gilled fleshy fungi*, Wm. C. Brown, Dubuque, Iowa, 1973.

* Tosco, U., *The World of Mushrooms*, Orbis, London, 1973.

† Wakefield, E. M. and Dennis, R. W. G., *Common British Fungi*, Gawthorn, London, 1950.

† Watling, R., *British Fungus Flora 1. Boletaceae: Gomphidiaceae: Paxillaceae*, HMSO, Edinburgh, 1970.

† Watling, R., *Identification of the larger fungi*, Hulton, Amersham, 1973.

† Wilson, M. and Henderson, D. M., *British rust fungi*, Cambridge University Press, 1966.

† Zeitlmayr, L., *Wild Mushrooms*, Müller, London, 1968.

SPECIES INDEX

Numbers in **bold** type refer to illustrations

INDEX

Numbers in **bold** type refer to illustrations.

Printed in England by W. S. Cowell Ltd, Ipswich